D1501937

THE PHOTOGRAPHER'S PROJECT BOOK

THE PHOTOGRAPHER'S PROJECT BOOK
Shooting like a professional

Jeanne Griffiths

Macdonald

A Macdonald BOOK

© Jeanne Griffiths 1984

First published in Great Britain in 1984
by Macdonald & Co (Publishers) Ltd
London & Sydney

A member of BPCC plc

All rights reserved
No part of this publication may be
reproduced, stored in a retrieval system,
or transmitted, in any form or by any
means without the prior permission in
writing of the publisher, nor be
otherwise circulated in any form of
binding or cover other than that in
which it is published and without
a similar condition including this
condition being imposed on the subsequent
purchaser.

British Library Cataloguing in Publication Data
Griffiths, Jeanne
 The photographer's project book.
 1. Photography
 I. Title
 770'.28 TR146

 ISBN 0–356–10166–5

Designed by Sarah Jackson

Filmset by Text Filmsetters, Orpington, Kent

Printed and bound in Great Britain by
Hazell, Watson & Viney Ltd,
Member of the BPCC Group,
Aylesbury, Bucks

Macdonald & Co (Publishers) Ltd
Maxwell House
74 Worship Street
London EC2A 2EN

Preface

A book of projects for the photographer is a clever and very sensible idea. Every photographer has to learn how to pick out a good shot from all around him and react quickly to it, and I've no doubt these projects will encourage you to do that.

I like to take a camera with me whenever I go out, with the distance set at about 4 metres, the speed at 1/125th of a second, and the aperture according to available light. In this way, with the great versatility of the 35 mm camera, you can grab a picture instantly without having to stop to focus. All too often, if you are not prepared, the picture will have gone.

No one needs special equipment for this – I use a 50 mm lens most of the time. Two cameras can be very useful, however, one with a 50 mm f1.4 lens and the other with a 135 mm lens; I also carry a spare 35 mm lens. I have always tried to use film of the same speed, preferably a fast one, because after a while it becomes second nature to get the right exposure. It also helps if you can develop your own film and examine it by the safe light while it is still in the developer, then give it more or less development as the case may be.

Use a camera with a quiet shutter, if you can – it will help you to get candid shots without unduly disturbing the subject. I have also found it very useful, when photographing someone for a photo-interview, to have a friend talk to the subject and take his mind off the camera. You will get much more natural shots in this way.

The use of light is a very important skill to learn. I can't resist shooting against the light and have got some wonderful results by doing so, but never let the full rays of the sun into your lens; use a good lenshood. When shooting indoors try not to use flash, but make use of the available light, even if it is only from a candle; your shots will be far more natural. Never think that there is not enough light.

The main thing, of course, is to take lots of shots and experiment, and don't be afraid to take a chance. Some projects may call for local help – so go out, talk to people and find what is going on. That's the way to take g pictures.

Misty and foggy weather can be wonde to photograph, especially if there is sn around. Try to include a bold piece of fo ground that clearly stands out, such as branches of a tree, and you will find that background will disappear gently into atmosphere. Movement is another great he in getting an unusual picture. I once had photograph 'Loneliness in a Big City', so I g a girl holding her suitcase to stand still on busy railway station with crowds of peop rushing past. I worked at a slow shutter spee of 1/10th of a second, so that everyone aroun her was blurred but the girl stood there on he own.

Good luck with your first project.

Bert Hardy
Limpsfield Chart, 1984

h
lp
to
ot
a
le
d
d
r

Contents

Introduction 11
The Picture Essay 13
The Mosaic 15
The Camera as a Tool 17
Using Light 21
Exploiting the Camera Angle 24
Preparing for an Assignment 26

The Projects 27

1 A Day at the Races 29
2 Pattern in Architecture 38
3 Group Activities 43
4 Local Industry 53
5 Town and Country Animals 62
6 A Craftsman at Work 68
7 Take One Tree 73
8 Shadows and Silhouettes 74
9 Bad Weather 77
10 An Event 79

11 Windows and Doors 87
12 A Day in the Park 88
13 The Way It Looks Today 93
14 Abstract Form 94
15 Early Morning 96
16 Communication 100
17 Pattern in Nature 108
18 Street Art 111
19 Market Day 114
20 Shapes and Symbols 125
21 Views From a Window 128
22 Primary Colours 129
23 A Day in the Life 131
24 My Street 139
25 Reflections 141

Subject File 147
Picture Editing 151
Using Your Pictures 156
Further Reading 159

Acknowledgements

Grateful acknowledgement is due to the 3M Company for generously supplying 100 ASA and 400 ASA 35 mm colour reversal (transparency) film, and Ilford Limited for supplying FP4 125 ASA and HP5 400 ASA black-and-white film, which was used to photograph the projects in this book.

Special thanks to the Cipher Dance Group of Brighton, Rosemary Eakins, Goddard and Gibbs Stained Glass Studios of London, Bert and Sheila Hardy, Jill Hailey of Joan Scott Public Relations Company, Tom Hawkyard of the 3M Company, Tony Lavender of Ilford Limited, and Alexander Low for their kind assistance.

The Illustrations

All the photographs in both colour and black and white were taken by the following:

Bryan and Cherry Alexander (professional): pp. 49–52, 95.

David Osborn (professional): pp. 24, 30–7, 80–6, 97–9, 112, 120–4, 126, 132–8, 152.

Jeanne Griffiths: pp. x, 17, 25, 28.

Tim Jemison: pp. ix, 55–61, 63–7.

Mark Karras: pp. 16, 75, 89–92, 101–4.

Leila Kooros: pp. 22, 39–42, 69–72, 105–7.

Paul Reeves: pp. 23, 44–8, 109, 115–19, 142–6.

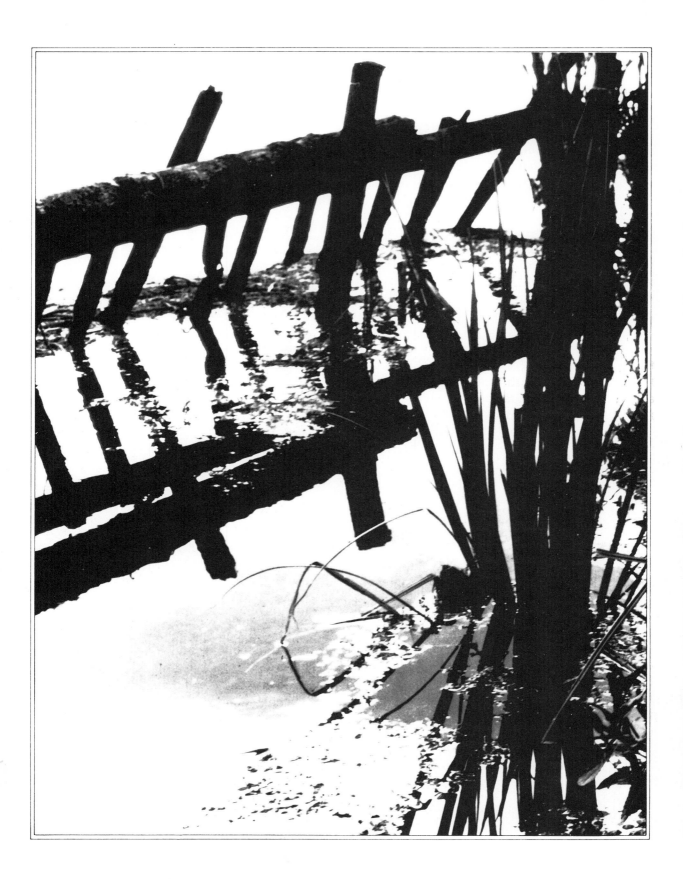

Introduction

There are hundreds of books that tell you *how* to take pictures. This one tells you *what* to take, giving twenty-five assignments which can be shot by anyone, anywhere and at almost any time.

By the time you reach for this book, you should have already mastered all the basic technical aspects of photography. You should be fully familiar with your camera, however simple or complex, to the extent that your reaction to it is like that of driving a car — automatic. This familiarity only comes with practice, and learning how to take better pictures comes from going out and shooting them, and then examining what is good or bad about them. Photographers spend a lot of money on all the 'hardware' — the lenses, tripods, filters, and so on — but often seem reluctant to spend any money on film. One shot, be it colour or black and white, costs very little in proportion to the price of a camera, so don't be mean. Learn to take that chance shot, and to experiment, for only if you actually use film will you find out what you are capable of.

For the projects in this book you do not need expensive, sophisticated equipment, and although for some assignments long and wide-angle lenses are useful, they are not essential. International photojournalist Alexander Low once told me that if you cannot take a good picture with a simple camera and a standard lens, you cannot take a good picture. All the equipment in the world will not help you see a good photographic opportunity. Having mastered taking successful pictures with simple equipment, you can then go on to use other lenses to achieve different effects. The camera is purely a tool with which to capture the image you have seen and thought about.

So, there you are with camera and film at the ready — but what should you photograph?

Someone once said that 'limitation is the springboard of inspiration' and that is what this book hopes to prove. By setting specific assignments, to be shot in a photojournalistic way with the subject set and the time limited, I hope to provide a point of departure. Each project allows the photographer to interpret it in his or her own way, creating a set of pictures on each subject that together tell a story. The assignments have been kept fairly simple, because if you are too ambitious too soon, you will flounder. However, each project can be as difficult as the photographer wants to make it, allowing every opportunity to exploit technical knowledge and photographic talent.

The time allowed has been limited as any professional assignment would be. This imposed limit will help you to discipline yourself to go out and find the pictures rather than putting off the moment. It should also encourage you to make appointments where necessary and to turn up and complete the job in the time you have available. Some projects, such as 'A Day in the Life' and 'A Day in the Park', must be shot in one day as light conditions and weather change daily; this will otherwise show in your pictures and disrupt their continuity.

Some projects need research, so time has been allowed for that, as well as for travelling to different locations. This time limit will help to keep the momentum going so that you complete the project by the deadline. The set time assumes that you are taking pictures in your spare time and so, within a limited period, you will have to work intensively on one project and watch every moment for possible pictures. I suggest that you concentrate on one project at a time; if you try to do too much at once, you will miss some good shots in the confusion.

The projects are mainly to be shot out of

doors, so no complicated lighting is needed. Any that need to be shot indoors can generally be taken with available light.

To illustrate the book, and to prove that no two photographers will treat the same assignment in the same way, six photographers, two of them professional, were commissioned to shoot the projects. The results illustrate the different approaches of style and technique, as well as how professionals approach an assignment. The analysis of pictures and projects aims not only to point out the strengths and weaknesses of a particular shot, but to show how a successful picture essay or mosaic depends on the relationship between all the shots that comprise it.

By looking at how the amateur 'guinea pigs' have dealt with each assignment, there is a lot to be learned from both their achievements and their mistakes. The selection of pictures from each shoot obviously plays a crucial role, so I have decided to include one of the contact sheets to show how the selections were made for this book and whether any shots were cropped. There is also a section on picture editing in general for essays and mosaics (see p.151). By concentrating on the picture essay and the mosaic of pictures rather than on one-off shots, the assignments will make you go out and look for photographic opportunities and so develop your talents to make you a better photographer.

The Picture Essay

The picture essay is the ultimate form of photojournalism and is one of the most complex and interesting ways of using pictures. Every picture essay has one strong theme, be it on a person, country, or event. It can be organized either chronologically or thematically, and although each picture *must* add something new to the story, the essay as a whole should give a fuller and more intense view of the subject than any one picture could achieve. The length of the essay clearly depends on the complexity of the subject and the detail in which it is to be covered, and so can vary from as few as five to twenty-five or more shots. Creating a picture essay involves the process of picture editing (see p.151), and in professional circles this usually involves a second person, the picture editor, and perhaps also a designer, as the way in which the pictures are laid out in a book or magazine is an integral part of how well an essay works.

Photojournalists are journalists who use pictures instead of words to tell a story, but the thought process is very similar. Each picture contributes another piece of information to make the story or essay complete. One great photo-essayist, W. Eugene Smith, once said:

A photo-essayist is a man who manages to comprehend a subject – any subject, whether it's coal miners in Appalachia, or love, or mercury poisoning of human beings in Minamata – and gives a lot of thought to weaving the pictures into a coherent whole in which each picture has an interrelationship with the others. Just having a long story doesn't make an essay. You can take a group of pictures all in the same place, on the same subject, and lay them out to make a powerful visual statement, but if they don't reinforce each other, then you haven't got a picture essay.

As mentioned, there are two ways to approach the picture essay. One is chronologically, which would be the obvious way of dealing with 'A Day in the Life' or a study of a craftsman at work. It is not, however, a 'how to make a chair' sequence; it is not a step by step instructional set of pictures which the viewer can follow and then also make a chair. On a craftsman, it would be an account of the man at work, his environment, the materials he uses, the concentration needed, the people he works with, and so on, shown by pictures of his workshop, close-ups of his hands, details of what he is making and the preparation needed, and of course the finished product.

Two of the most important pictures in an essay are the first and the last. It could, for 'A Day in the Life', be a simple portrait of the subject or a shot of the morning paper on the doorstep – something that catches the interest of the viewer and yet gives an indication of what the story is about. For an essay on the craftsman, the opening picture could be a close-up of his hands at work, without showing exactly what he is making. It informs and yet intrigues. Or it could be a picture of the finished product, so the viewer goes on through the essay as if it were a flashback to the making of the product. The final shot in the essay could also be the finished product – so long as something else has been selected to start. It could not reappear in both places, as it would be repeated information. Each picture must add more, but not the same, information to the story.

Some pictures would, if used in publication, naturally be larger than others, not because of the size of the subject, but because of its importance to the story. Others, called point-pictures, because they are making a small point in the story, would be used small or perhaps inset into a larger picture.

14

If you chose to interpret the assignment on 'Local Industry' as sheep farming near where you live, a good point-picture would be a close-up of the brand mark. The opening picture could be a shot of a pile of fleeces – taken to fill the frame completely – or a dramatic shot from above of sheep in a pen. The last shot might be the shepherd relaxing after a long day's work, or even a row of woollen sweaters in a shop window. Always follow a story right through to its conclusion. Stop too soon and you have not created a picture essay.

The other way to treat a picture essay is to cover a larger story, but one which still has a strong theme. For craftsmen or industry, you could cover all types of craftsmen in one essay, with shots of the different techniques needed for each type of craft and the variety of results displayed by proud makers or for sale in shops and markets. If for 'Local Industry' you selected agriculture as a more general overall theme, then ten big, dramatic shots of each type of agricultural activity – from ploughing fields and harvesting corn to milking cows and herding sheep – would tell the complete story without ever repeating the information.

Professional photographers go on such assignments armed with a 'picture script' (see p.26) – like the projects set in this book, but on specific markets, people, crafts, and events. These scripts contain a lot of research about what time things start, who to see, specialities of the area, and so on. A little research can save a lot of time and trouble – it is no use turning up to shoot the milking of cows an hour late or to arrive at a motor race when the cars are already under starter's orders. You need time to look around and find the best positions, and to cover the whole story, not just part of it. By thinking about telling a story with pictures, you will look for, and find, exciting photographic opportunities that you would otherwise have missed.

The Mosaic

Like the picture essay, the photographs that make up a mosaic concentrate on one theme, although that theme is far more restricted and usually of more graphic images than the picture essay. A mosaic is a study of design, form and shape, all by using pictures based around one specific subject. If you photograph an interesting door, you will notice its colour, texture, shape, and architectural details. If you photograph eight more interesting doors, you have a powerful visual statement on the variety of designs, colours, and shapes used in doors. Nine examples are a good number as they allow you to photograph enough of your subject without overstretching a simple idea, although there is no reason why it should not be more. Also, nine same-size prints of nine interesting doors, or windows, or shop signs, placed together in one frame, make a good balanced set for hanging on the wall.

Some subjects are more sympathetic for use in a mosaic, such as a series of shots of one symbol found in a variety of situations, whereas 'A Day in the Park' is a 'bigger' subject and more suited to the picture-essay format. Signs and symbols make excellent subjects – the dragon, for example, which, once looked for, can be found in architecture, paintings, posters, on T-shirts, pots, and in a great variety of other places. Once you have chosen a subject your awareness of it heightens, encouraging you to search out more examples to photograph.

Make sure that you fill the viewfinder with your subject or else crop into it later; too much background distracts and makes a simple image confusing. Shoot either all in colour or all in black and white, as mixing the two will also diffuse interest and produce an unbalanced set of pictures, with the colour dominating over the black and white. Mosaics are most pleasing when shot in colour, but some subjects, such as statues and carvings, are just as successful in black and white. If the colour is a very important part of your subject matter then shoot in colour, but if it is the shape, tone, and texture that attracts you to the subject then consider shooting all your examples in black and white. Each picture should have the same degree of strength, in light, texture, and tone, and be chosen because it is different from, but as interesting as, all your other examples on one theme.

It is not essential to shoot all the pictures either all vertically or all horizontally, but it is important to use the shape of the film sympathetically to your subject.

A mosaic gives the ideal opportunity to exploit Polaroid, which gives instant pictures of the same size that can be mounted together as one design. They can also be easily cropped if the subject does not fill the frame.

Cameras and Lenses

The assignments in this book are generally geared towards use of the 35 mm single lens reflex camera (SLR), which most photo-journalists prefer. It is flexible and reasonably light in weight, has a through-the-lens light meter, and allows you to change lenses and work at speed. There is no reason, however, why the projects cannot be successfully shot on a 110 format camera, many of which now have an inbuilt telephoto lens. The small size of these cameras makes them convenient for travel, but because the film size is smaller they are not suitable for pictures which are to be blown up or reproduced.

The range-finder camera, which holds 35 mm film, is less expensive than the SLR and comes with a fixed lens in the 40 mm range – a moderate wide-angle. They are often semi-automatic, allowing you to focus and set the speed while automatically adjusting the aperture. The quality of the picture is improved by use of the larger-size 35 mm film, but as the lens cannot be changed there is a limit to the pictures that can be taken.

The large format SLR camera uses 2¼ inch square film and has interchangeable lenses. It is not held to the eye, but you look down into the viewfinder. It is excellent for portrait and studio work, as the larger-size film gives high quality results. It is not widely used in photo-journalism, however, as it is bulky and cannot be used at speed. Also, many photographers prefer the proportions of the 35 mm film to the 2¼ inch square.

The 35 mm SLR camera allows through-the-lens viewing, showing the picture exactly as you are going to take it. It allows you to use a wide variety of lenses and gives greater control over the speed and aperture than the range-finder camera. Some are automatic, with a manual override facility; you can thus concentrate on the subject and composition while the camera takes care of the exposure. Once familiar with automatic you can then switch to manual, which will enable you to experiment with exposures and speeds.

The SLR system usually comes with a 50 mm normal lens, which shows the picture at the same size as you see it with your eye. A good companion to this is a wide-angle 28 mm lens, which has a greater field of view but without too much distortion. Alternatively, a 35 mm wide-angle could be used in place of the 50 mm and 28 mm lenses.

A longer lens allows you to get closer in on your subject without actually moving towards it; it is a great asset for portraiture and candid shots. The 105 mm or 135 mm are both very good, or you can opt for a zoom lens and have a combination of focal lengths in one lens, allowing you to frame your picture at any focal length in the range without moving. One of the most popular is the 80–200 mm. The disadvantage of a zoom lens is that one often spends so long zooming in and out of the subject that the light may have changed or the moment been lost. The cheaper versions of the zoom lens do not have the optics to allow you to shoot in poor light, and as they are quite heavy you need enough light to shoot on at least 1/125th of a second to avoid camera shake. They also tend to be more difficult to focus than the set-length lenses. A moderate wide-angle, such as the 35 mm, a 105 mm or 135 mm set-focus lens, and a longer 200 mm set-focus lens makes a good SLR system to begin with. A lenshood is a useful addition for shooting into the sun.

If you are interested in sport or wildlife, you may consider an even longer lens of 300 mm or more. Lenses do go up to 2000 mm, but become unwieldy and need to be placed on a tripod. Some long lenses have been shortened by use of mirrors, giving the 'bubble' effect on background as seen in sports pictures. Very long lenses make the picture appear compressed, adding intensity to a row of buildings or to a crowd.

Motordrives are not necessary unless you are very keen on sports photography, when you need to work fast, and in general lead to lazy photography – allowing film to roll on without considering each shot. They are, however, useful for news photography where

composition often takes second place to 'getting the picture'.

For studying things in close detail a macro-lens allows you to move in very close, far closer than a standard 50 mm lens. Extension rings can be used to extend the lens from the camera body in order to increase magnification. They are available in various sizes, depending on how close you need to get to your subject, and can be used singly or in sets. Alternatively, an auxiliary lens can be screwed on to the front of a normal camera lens, such as the 50 mm, to shorten the lens-to-subject distance and so increase magnification. An extension bellows, which is fixed between the camera body and the lens, allows excellent close-up focusing.

Filters for Black-and-white Film

There are hundreds of filters on the market offering a variety of effects on black-and-white film, but a basic set could be made from the following.

Yellow	Absorbs ultra-violet and some blue. Darkens blue sky, accentuating clouds.
Deep Yellow	Absorbs ultra-violet and most of the blues. Similar effect to yellow filter, but more pronounced. Darkens blue water and lightens any yellow subject in the picture, such as flowers or clothing.
Red	Absorbs ultra-violet, blue and green. Turns blue sky and water very dark, increases contrast and deepens shadows. Lightens red and cuts out haze.
Green	Absorbs ultra-violet, blue and red. Slightly darkens sky, but lightens foliage. Makes red objects darker and deepens skin tones in portraits.
Blue	Absorbs red, yellow and green. Lightens blue objects and increases haze in landscapes.

Neutral Density	Absorbs all colours in equal proportions. Reduces exposure, enabling a slower shutter speed or wider aperture to be used.
Polarizing	Helps eliminate reflection off glass, water, and similar surfaces. Darkens blue skies if used at right angles to the sun without affecting the colour of the landscape.
Ultra-violet	Absorbs ultra-violet. Cuts haze in landscapes, giving a sharper image. It is particularly useful at high altitudes. A good filter to keep on the lens to protect it from dirt and scratches.

Filters for Colour Film

1A Skylight Filter	Warms up scenes with excessive blue, such as aerial shots, snow scenes, and overcast cloudy daylight.
80A	Converts daylight film to a tungsten film.
85B	Changes tungsten film to daylight film.
Tiffen FLD	Corrects the effect of fluorescent light on daylight film.
Tiffen FLB	Corrects the effect of fluorescent light on tungsten film.

The ultra-violet and polarizing filters can be used on colour film with the same effect as on black and white. Remember to use a soft cloth or brush to clean the lens and filters, but do not rub hard or you may damage the coating.

A sturdy tripod is essential for long exposures when there is not enough light to hand-hold the camera. Use a cable release, which allows you to release the shutter without touching the camera and so eliminates camera shake.

Most cameras have a built-in light meter powered by batteries. These must be checked regularly, as although they may not be 'dead' old batteries may give inaccurate light readings, resulting in wrongly exposed

pictures. After you have finished shooting always make sure that the battery is switched off, the lens cap is on to protect the lens, and that the shutter has been released. It is not good for your camera to leave it wound on, as this puts unnecessary pressure on the springs.

Film

The slower the speed (the ASA) of the film, the more definition and less grain in the picture. However, slow films need good light to enable you to shoot on 1/125th of a second, which is the lowest speed on the camera that does not show camera shake. Higher speed films of 200 ASA or 400 ASA enable you to shoot in poorer light. Use colour tungsten film when shooting with artificial lighting.

Colour versus Black and White

Some subjects naturally lend themselves to black and white, such as hardship, war, or a story on, say, nuns. Black-and-white film can add intensity to a subject where colour would only distract. It has an urgency and sombreness, while colour 'prettifies'. It can lead the eye to a detail which might be lost in a flood of colour.

In photographs where texture, tone, and shape are the most important elements, black and white allows you to concentrate on those features. Such pictures seem more serious than they would in colour and can often capture an atmosphere and emotion that in colour would seem softer and confusing. Colour pictures make most things look attractive – even a derelict building. The same building photographed in black and white makes an urgent and sombre statement about decay, while in colour it may appear more as an assembly of interesting shapes and shades – a study in design. Subjects that are 'fun' or beautiful because of their colour, such as a parade or garden, are enhanced by the use of colour film. They do not need the dramatic quality or immediacy of black and white.

When deciding which to use for the projects, consider whether the subject has or needs the urgency of black and white. 'Local Industry', where people will be working with machines and very busy, lends itself to black and white, whereas 'A Day in the Park' is likely to be full of pattern and activity, and people enjoying themselves, and so is more sympathetic to colour. Some projects, such as 'Early Morning', can be successfully shot in either; the grain of black and white will be as interesting as the muted tones of colour film. Pictures of murals for 'Street Art', for instance, would lose their impact in black and white, yet graffiti, usually political, has a news quality and urgency more suited to it.

In a picture essay or mosaic, however, colour and black and white do not mix well, so stick to one or the other. If you have two camera bodies, it is useful to have one loaded with black-and-white and the other with colour film, so that you can first try out any projects in both and assess which works best later. If you are shooting in colour, it is worth remembering that a black-and-white print can be made from a colour transparency, although some quality may be lost. If your colour pictures are intended for publication, always use transparency film, never colour print film.

Using Light

The rule for beginners used to be 'stand with the sun behind you and photograph in bright sunlight for the best effect'. The results, of flat faces squinting into the sun, were awful. It is the quality of the light, not the quantity, that makes for good pictures. The best light comes in the early morning or late afternoon, as it has qualities that bring out muted colours and deeper shadows, and is, on the whole, far more interesting than those 'truer' colours of midday. The brain seems to accept that colours under a cloudless sky when the sun is highest are how they should be, but the end result, although bright and cheerful, is invariably flat and unremarkable. Hills and trees, the mind tells us, are green, but if you look at them at dawn or dusk, they pick up blues, pinks and purples.

Although the mind may precondition our perception of colour, the camera is not so easily deceived. Colour film reproduces what it sees, although the colour quality and balance may vary slightly from make to make. It is worthwhile getting up before dawn and watching the blackness turn into a cool, bluish light. As the sun rises, the light changes dramatically and becomes warmer, with the blue hues being filtered out by the air. Shadows also have colour, turning from blue to black by midday. In summer, when the sun is at its highest, the contrast between colours is strongest, and since there is no colour in the sun's bright light everything will stand out in its 'purest' colour, but not necessarily the most interesting.

As the sun goes down, the light begins to warm in tone. Shadows lengthen and become bluer again; textures are more subtle. Even after the sun has set, the light still gives a glow to the sky. Try a series of shots so that you can discover the changing qualities of light at different times of day.

Early morning mist can produce some marvellous atmospheric pictures, giving a surreal and eerie quality to a landscape. There must be enough light to produce colour, however subtle, and a tripod might be required as exposures may be long. Check the meter reading regularly, as the light increases very quickly at this time of day. Remember to bracket each shot; half a stop up can give a bright, transparent effect, while half a stop down will produced a richer quality.

The late afternoon is one of the most rewarding times for photography, as colours acquire a rich mellow quality. Again, check the meter reading regularly as the sun goes down quite rapidly. The twilight that follows can give yet another quality to a picture. It is a marvellous time to photograph towns and villages, as house and street lights are just beginning to come on, but it is still possible to see streets and houses as more than silhouettes and shapes. If you use fast film and a fast lens, the camera should be all right held in the hand, but with slower film you will need a tripod or wall on which to rest your camera. You should also bracket by a couple of stops, as twilight is difficult to gauge.

Night shots will require a tripod, especially if using a long lens which magnifies camera shake. The longer the exposure, the *less* sensitive film becomes in night shooting.

Don't let bad weather put you off. There is one project in the book specifically on bad weather, as it is a fallacy that good pictures can only be taken in good weather. By using high speed film, you can overcome bad light and actually exaggerate the conditions. Shots in fog and mist can be very atmospheric, but remember to bracket all shots, not only to compensate for light that may be reflected, but to experiment, for over- or under-exposing can produce some exciting results.

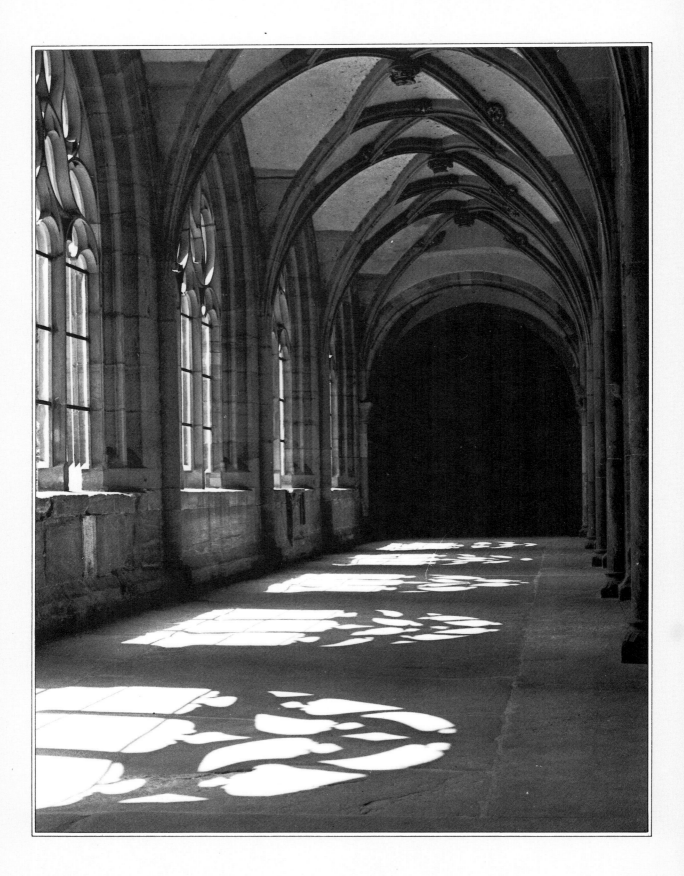

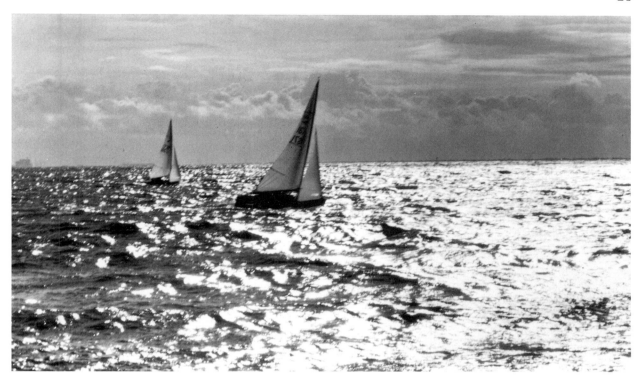

Opposite: *It is the pattern on the floor of the church, made by the light pouring through the windows, that makes this picture interesting. Using a 35 mm wide-angle lens, the photographer had to lean against a pillar to steady the camera, as the shot required a slow shutter speed of 1/30th of a second to ensure an aperture of f4.*

Above: *Photographed in late afternoon, this shot uses the light reflected on the water to make it dramatic. Other shots of the same subject, taken earlier in the day, were less successful as the light was flatter. The photograph was taken on a 50 mm lens and there was enough light to allow a speed of 1/125th and an aperture of f5.6.*

Try also 'pushing' the film, that is, rating it at a higher ASA on your camera than is stated on the cassette – but remember to mark the new ASA on the roll, as you will need to know its new rating for development. Do not push Kodachrome 64, however, as not many Kodak dealers will handle it and those that do charge highly for the service. Other films can be successfully pushed by two or three times the amount stated, although some quality may be lost. However, by increasing the ASA you will be able to use the film in bad light conditions, as you have effectively made it a high speed film and so more sensitive.

If you have filters, experiment with them and try the same shot with each so that later you can examine the results. Note which filter was used for which shot – you always think you will remember, but rarely do.

Snow tends to reflect light, so take a close-up reading from a shadow or mid-tone of your point of focus, rather than from the snow itself. Do experiment with other exposures, however, as some marvellous and strange effects can be achieved by deliberately under- or over-exposing. A polarizing or ultra-violet filter will help to cut out glare.

Always be aware of the direction of the light when photographing. Move around, look at pictures taken at different times of the day and year. Light is changing in direction and quality all the time, but the only way to understand its effects is to go out and take some pictures. Use film and experiment.

Exploiting the Camera Angle

The first thing to get used to is to know when to take either a horizontal or a vertical picture. Most inexperienced photographers see a good shot, hold the camera horizontally and then shoot, without even looking at the possibilities of a vertical shot. Many pictures have better composition and more impact when shot vertically, although there is no rule – other than trying it. Most people almost instinctively shoot trees vertically because of their shape, but look also at a horizontal shot. The next thing is to learn to move around your subject, studying it from all angles, looking through the camera held both vertically and horizontally. Think about the light source, and the background; by moving, sometimes only a few feet, you can remove from view a cluttered or dull background that distracts from your subject, or you may find something interesting to include.

If a group is posing for you, think about where you want *them* to be and move *them* into position.

It is also important to learn to move up and down. A shot taken kneeling or lying on the floor can introduce a dramatic element that would otherwise have been missed. Remember to check the light meter, as if you are shooting up you will include a lot of sky and more light than if you shoot straight ahead. Take a reading quite close to the subject or angled down away from the sky. A building or tree in the distance will look much the same whether you are kneeling or standing, but taken close-up will appear to be towering over you. A wide-angle lens will emphasize the size and perspective of your subject. A shot of someone diving from a high board will not be very dramatic taken from the other end of the pool. Try lying on your back at the pool's edge beneath or to one side of the board.

Children and animals also benefit from being photographed at their own level. By moving yourself around and trying every possibility you will find a new perspective on even the most familiar subjects.

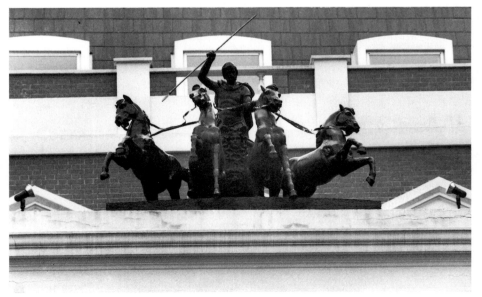

Left: *A 135mm lens enabled the photographer to shoot up towards this sculpture, so getting in close enough to make it the subject of the picture, while the angle emphasizes its size. By shooting straight on, but looking up, the symmetry of the sculpture is made plain, which produces the power of the picture. It was taken at 1/125th of a second at f5.6.*

Opposite: *Using a 28mm wide-angle lens at 1/60th at f8, the photographer knelt down to shoot up towards the church.*

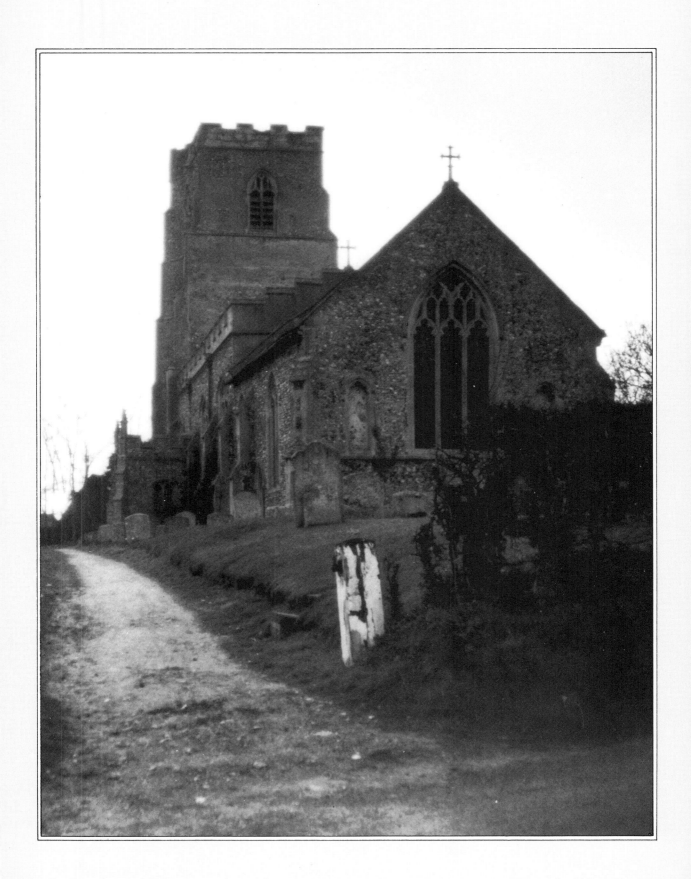

Preparing for an Assignment

Select one project from the book and prepare a shooting script before embarking on it. By writing down ideas for possible shots, not only by subject matter but by approach, you will ensure that you cover the subject fully. By concentrating on one project at a time, more ideas will come to you than if you try to handle several at once. A shooting script will help focus your attention and heighten your awareness of a subject; a professional photographer would always use one.

Read through each project and consider elements that you think you can effectively shoot and expand on. If the project requires sequential shooting, write out a list of every possible activity concerned in chronological order. Note the time an event starts, or when stalls are set up in a market, so that you can judge the right time to be there. If the project requires some research, such as finding places connected with someone famous, make a list and arrange them in a sensible order for convenience of location, times of opening and so on. Next to your list of what you are going to photograph write down possible types of shots, from close-ups through to long-distance ones, making sure that you have a good balance. You may end up shooting the project differently, but the more you have thought about it beforehand, the better prepared you will be. Consider potential lighting situations and choose film and equipment accordingly — a checklist is useful, so that you do not forget anything.

For any assignment, you should first try to gather as much background information as possible, checking books, papers, and magazines for articles and pictures which may spark off ideas you would otherwise not have thought of.

The Projects

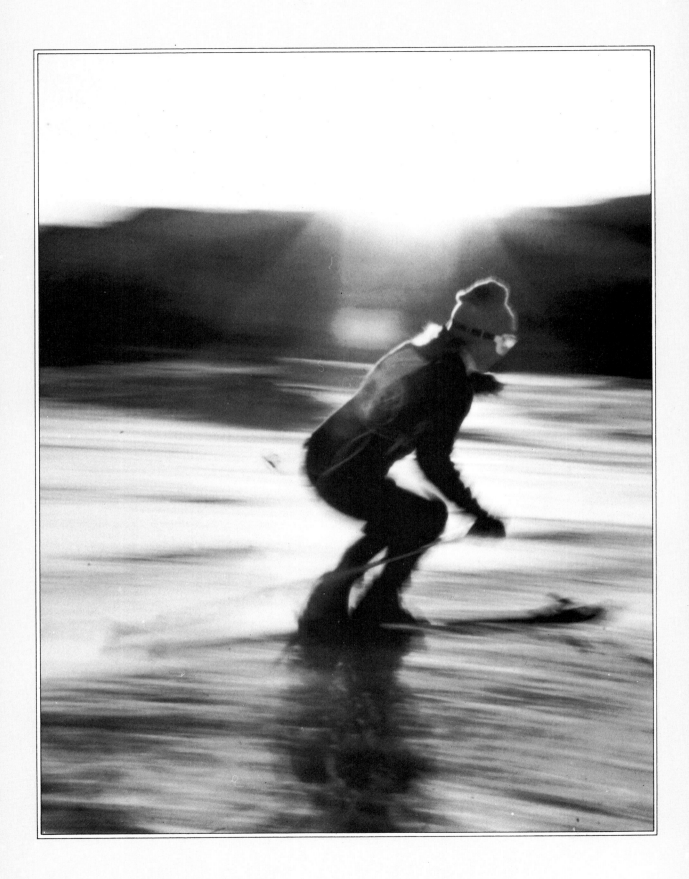

□ □ □ □ □ Project No 1 □ □ □ □ □

A Day at the Races

Time: one day. Picture essay.

Be it motorcycle racing, horse racing, canoe or car racing, a day at the races provides exciting possibilities for photographers. The actual races are only a small part of what happens and for a picture essay the race itself might only claim a couple of shots. The rest would be of behind-the-scenes activities and the crowds.

'Behind the scenes' will give information on the whole story – be it grooming horses or tuning cars – especially if you are able to buy a ticket that allows access from one area to another. You may have to ask permission to go behind the scenes, but with local events this is not usually a problem. Be polite and unobtrusive, and remember that the best photojournalistic shots are taken when the subjects are unaware that they are being photographed. A long lens can be very useful here. Have your camera ready and loaded all the time, and work quickly to capture those moments of joy, anger, or despair in both crowds and participants.

A subject of this kind is best approached with a combination of overall, medium-range and close-up shots. Fill the frame first with a shot of the crowd and then go on to shoot a series of close-ups of expressive faces – studying programmes, chatting, watching the event with rapt attention or even boredom, and so on. Your pictures should convey the atmosphere of the day.

You must arrive early, so that you can take an overall shot of the course before the crowds arrive. Then cover people arriving, including the competitors, and follow the activities of setting up food stalls, unpacking gear, tuning bikes, athletes limbering up, and so on. It is important to keep on the move, camera at the ready, looking for photographic possibilities and studying the best position to be in for the actual race. The winning post is not necessarily the best position as competitors may finish rather undramatically in ones and twos. An early turn on the course, when riders or runners are usually close together, makes a much more exciting shot, and can be exaggerated by using a very long lens to make the competitors seem even more tightly packed than they are. Choose a good position and pre-set the focus at the point where the competitors will come round the corner and into view. Unless you are used to working at speed, this will give you more time to think about composition. You can also set the exposure in advance, but remember to take into account the direction of the light, possible reflections off metal, and the clothes of the competitors, if these are dark. For a surfing or canoeing event, a polarizing filter should be used to cut out the glare from the water.

Dramatic effects can be achieved by standing to one side and panning with the subject. Taken at 1/8th of a second a panning shot will give an impression of speed by blurring the background and, to a lesser extent, the moving subject. The slower the shutter speed, the more blurred the subject will appear; at 1/125th of a second, on the other hand, the subject will be frozen and the feeling of speed lost. One problem with using a slow shutter speed is that it may allow in too much light. Even if you close the aperture as much as possible (to f16 or f22), the meter may still indicate this. Use a slow-speed film to compensate (for example, 25 ASA) or a neutral density filter which, depending on its strength (a variety are available), will reduce the exposure by several stops. A zoom lens can also be used to create a blurred effect, by moving the zoom from one end of its range to the other as you shoot. Do experiment with various shutter speeds and make a note of the order in which you took the shots.

An important part of this project is to explore different angles. By kneeling to photograph horses going over a jump, for instance, you will create the impression that they are

higher than they are. Shooting a surfboard with a long lens while you are lying on the beach can give the exciting result of making the surfer appear to be almost going over your head. There are plenty of other possibilities.

Don't worry about the weather – dramatic effects can be achieved in the pouring rain. By using a grainy, high-speed film, you can make bad weather seem even worse. Capture on film the mud flying as bikes go round corners and the crowds watch from under umbrellas.

A word of warning: a long lens may make competitors seem a long way off, but they are travelling at speed and can gain on you faster than you think. Be careful to stay out of the way and keep off the track.

The Essay

Shooting on 400 ASA black-and-white film and using two 35 mm SLR camera bodies and three lenses – a 28 mm, a 50 mm, and a 135 mm – David Osborn captured the drama of motocross. He sometimes attached a motordrive which enabled him to work fast to photograph those unpredictable moments, such as the beginning of the race. Although he took few pictures of the spectators, he did cover the behind-the-scenes preparations, which added balance and pace to the essay and led into the coverage of the race itself. The day was bright, but cloudy with no shadows. No filters were used.

To begin the essay, it was necessary to select a shot that set the subject for the viewer, but that did not give everything away at once. A very abstract shot seemed to be a solution, and of the many slow-speed shots the photographer took, this one makes the bikes just recognizable and yet leaves the viewer in no doubt as to what the story is about. It was taken on the 50 mm lens at 1/30th with the aperture at f8. The slow speed of 1/30th, combined with panning with the riders as they speed by, makes the abstraction interesting for an opening picture.

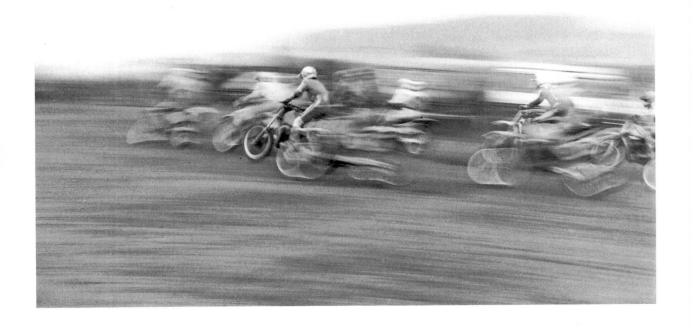

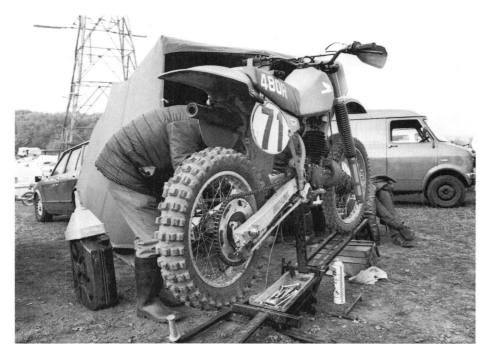

Left: *A wide-angle 28 mm lens makes the bike the prominent feature in this behind-the-scenes shot, with a mechanic preparing it for the race. Taken at 1/125th of a second at f5.6, the position of the bike on the ramp and the angle of the photograph emphasize the power of the machine, even though a lot of background can be seen. As a second shot, it gets quickly into the story.*

Below: *A close-up of mechanic and rider, taken with the 135 mm lens at 1/125th at f5.6, shows another aspect of preparing for the race, as well as including some of the crowd.*

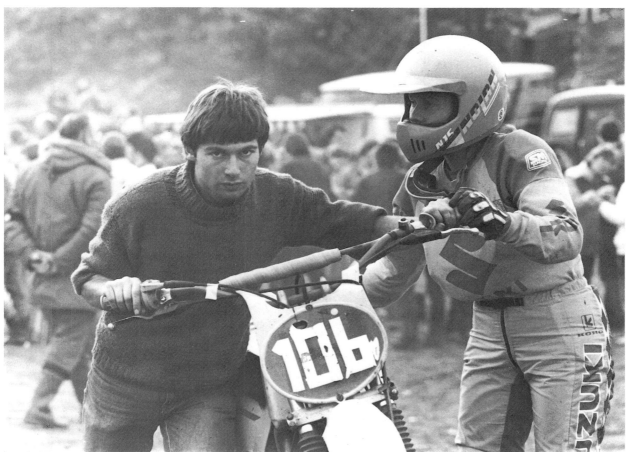

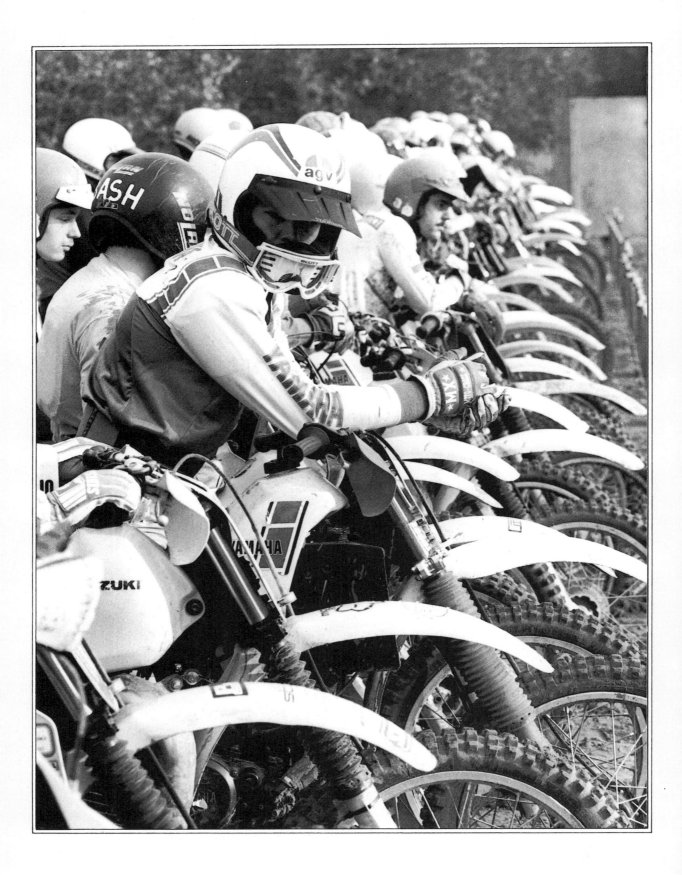

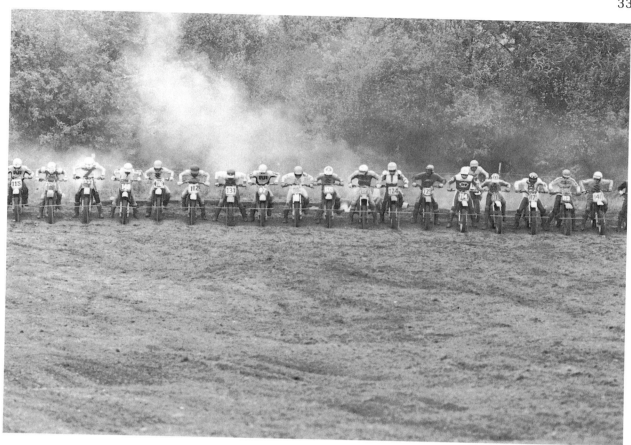

Above: *The photographer attached a motordrive to ensure that he caught all the action of the start of the race. Using the 135 mm lens at 1/250th at f4, he managed to include all the riders. The drama of the shot comes from the suspense of the moment – the riders lean forward in readiness, with smoke behind as they rev up their bikes – and this adds to the anticipation of the whole story.*

Right: *Prefocusing the camera on a patch of ground, the photographer waited for the riders to appear. The focal point of the picture is sharp, while the foreground is not, due to use of a wide aperture of f2.8 to compensate for a shutter speed of 1/100th of a second. Using the 28 mm lens, the picture catches the action coming straight towards the camera – their goggles and masks make the riders look determined and rather threatening.*

Opposite: *Taken with the 135 mm lens again, this picture makes the line-up of riders and bikes seem more intense. By filling the frame, with the line running away from the camera, it makes a dramatic shot. The speed was set at 1/125th and the aperture at f8.*

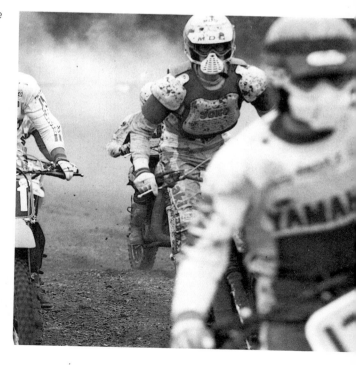

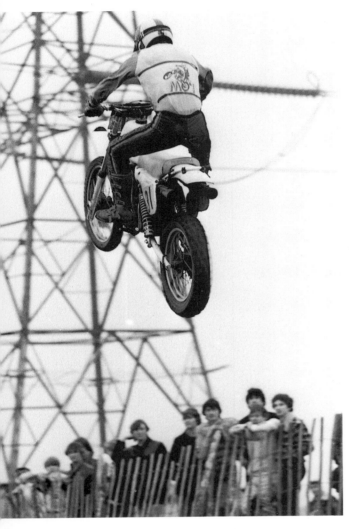

Left: *The photographer saw an opportunity for a dramatic shot on this part of the course. He took nine pictures of different bikes taking off from the ground before achieving this one. With the 135 mm lens he was able to preset the distance and pushed the speed to 1/1000th to freeze the action, which in turn forced the aperture open to f2.8. This has resulted in lack of depth of field, but the rider is very sharp while the pylon is slightly out of focus, giving scale to the picture while not overpowering its focal point.*

Below: *Capturing those unexpected moments means working fast. A rider has come off his bike, and out of five pictures on the incident this one had the most urgency, with one steward watching for other riders and a second steward running to help. Although the photographer missed the actual moment of the rider coming off the bike, this picture adds to the story by showing the hazards of the race – especially following the previous shot. Taken on the 135 mm lens at 1/1000th at f2.8.*

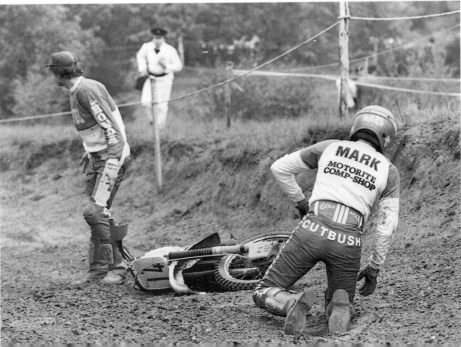

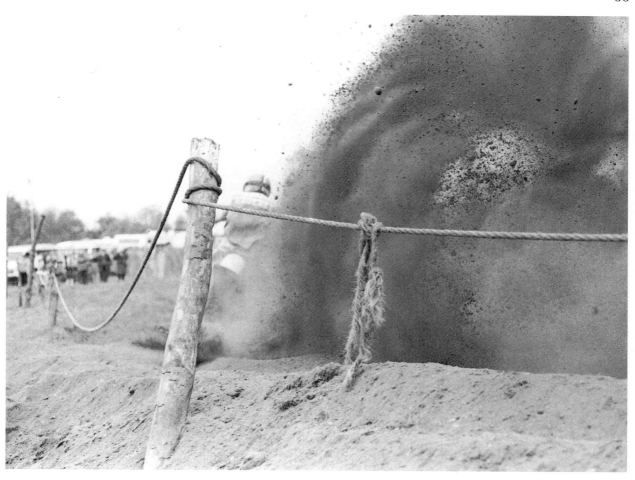

Above: *This was the first of fourteen shots taken from the same position and was the most successful, concentrating on the sweep of dirt but with enough of the rider to show what is happening. Taken on the 28 mm lens at f2.8 at 1/1000th of a second to freeze the action, the rider is framed between the thrown-up dirt and the post and line of ropes.*

Right: *A restful picture after the racing shots, but one that reminds the viewer of the dangers of the race by showing first aid officers out on the course. It was taken with the 50 mm lens at 1/60th of a second at f8.*

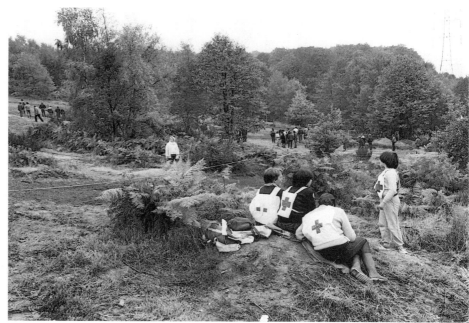

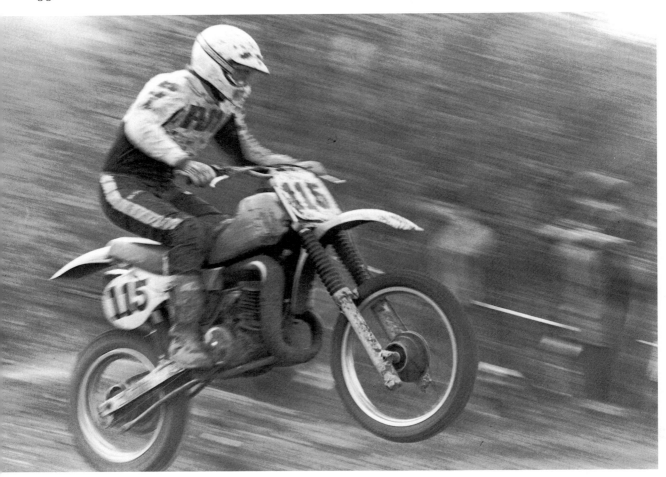

Above: *Back to a close-up of the action, using the 28 mm lens at f2.8 with the shutter set at 1/1000th to freeze the bike and rider. The sense of speed comes from panning with the bike, rendering the background as streaks of blurred figures and trees.*

Right: *The chequered flag indicates the end of the race, but to continue the feeling of speed in the essay, one of the fifteen shots of the finish was selected that showed a rider only as a very blurred figure racing by. It was taken with a shutter speed of 1/8th of a second at f11, again on the 28 mm lens.*

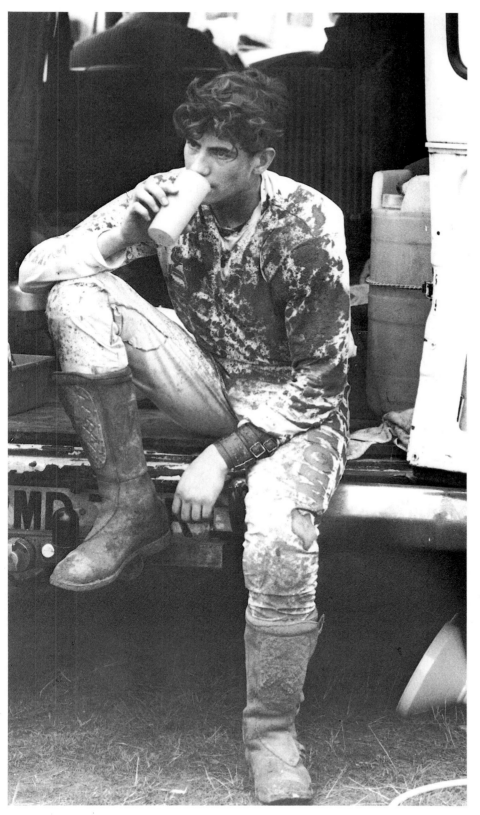

To finish the story, another behind-the-scenes shot was chosen – this time of a rider, evidently after the race as his overalls are covered in mud. Slightly under-exposed, taken on the 50 mm lens at 1/125th at f4, it is a restful picture – but one that makes it clear that this rider was not the winner.

Pattern in Architecture

Time: one month. Picture essay or mosaic.

Architecture gives the photographer a good opportunity to shoot pattern and understand the importance of line and tone. This series of pictures could be a mosaic or a picture essay, telling the story of man-made design through as many examples as possible. Rather than looking at buildings as a whole, investigate the details of design that make up patterns. The roof tiles of a house, shot to fill the frame, make an interesting textured pattern. Awareness of perspective will make for more powerful pictures – look where the lines of tiles converge and move around until this point is in the part of the picture that gives it most strength and makes the pattern seem more dramatic. It really is worth being free with film and taking several shots from slightly different angles, so that you can then analyse which pictures are stronger and why. Don't be afraid to include one disruptive element, such as a chimney or a pigeon sitting on the roof.

A shot along a row of houses, taken with a long lens, gives the impression that they are closer together than they actually are. The 'condensed' effect, combined with the repetition of similar buildings, will make a more powerful statement than a shot with a standard lens. Look for pattern in brickwork, walls, staircases, windows, and doors. By closing in on a wall, rather than shooting it together with its surroundings, you will find detailed patterns with interesting colours, tones, and textures. When shooting windows, it is advisable to use a polarizing filter to reduce reflection.

Buildings can be difficult to photograph as they appear, when taken from close up, to be falling over backwards. To minimize such distortion, use a long-focus lens from a distance and shoot from an elevated position, or shoot more of the building than you actually want and crop in later. There are, in fact, special perspective-control lenses which can be used to avoid converging lines, but unless you intend to shoot a lot of architecture they are probably not worth the expense.

It is not possible to control the light on a building, so study the position of the sun and think about where it would be early in the morning or late in the evening. If the light is flat and uninteresting, return at a better time or use a filter to give the picture a richer quality with more depth and tone. Harsh light can, however, create silhouettes of pattern, if chimneys, roofs, stairways, grilles, and other features are shot *against* the light.

The Essay

Leila Kooros used two lenses on her 35 mm SLR camera, an 80–200 mm zoom and a 50 mm (both with a 1A Skylight filter), to interpret this project. She covered a variety of styles of architecture, all but the third picture in the essay being shot on 400 ASA black-and-white film. The pictures were partly selected to show the history and various styles of architecture, although this was not part of the brief. However, on looking through the shots, it seemed a good way to use them. The use of the 200 mm focal length on the zoom has helped to make some of the rows of buildings seem compressed, so adding to the feeling of pattern.

This graphic essay gives order through pattern, which is pleasing to the eye, and tells the story of the variety of materials, textures, and designs used in architecture. The different sizes and shapes of the pictures add pace to the essay.

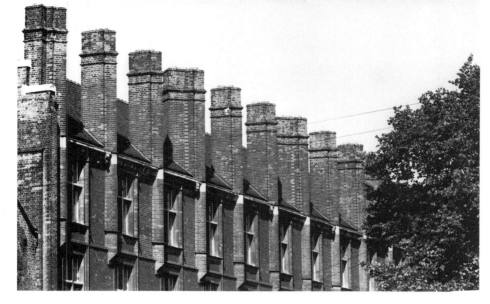

Left: *A row of chimneys and windows appears tighter together by using the zoom at its full 200 mm focal length. Part of the tree on the right was cropped out, so making the lines of the building cut across the picture. The speed was set at 1/125th of a second, with the aperture at f5.6.*

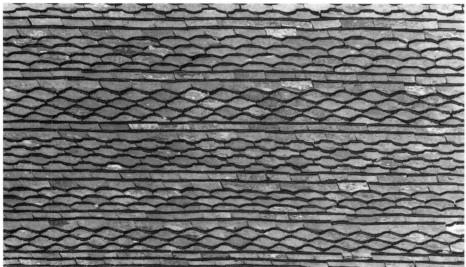

Left: *Moving in on the detailed pattern of old roof tiles, this picture, taken with the zoom lens, needed the full focal length of 200 mm to get in close enough for the tiles to fill the frame. Shot at 1/125th, there was enough light to use quite a small aperture of f16, giving a reasonable depth of field. Slight cropping along the top and bottom of the picture has corrected the horizontals, which are difficult to judge from a distance.*

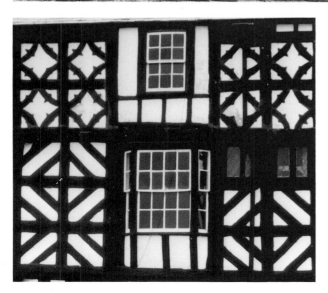

Left: *This picture was converted from a colour transparency. As the photographer happened to have a colour film in her camera, she was not going to miss the intricate pattern of the woodwork on this old building. It was taken with the 80–200 mm zoom at a focal length of approximately 135 mm at 1/125th at f5.6 and has been slightly cropped to show the detail better.*

Right: *To contrast with the diagonal lines of the previous shot and moving in closer on a section of a building, this picture was taken from the road, looking up, using the 80–200 mm zoom at 1/125th at f8. The distance from which the picture was taken has helped to keep the verticals on the window straight.*

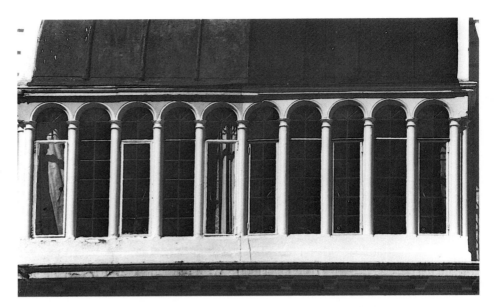

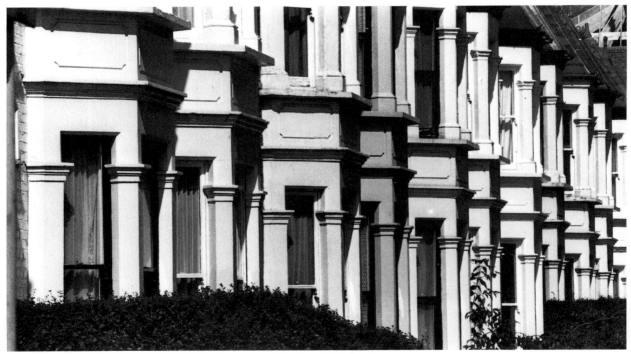

Above: *Another angled row of windows, but of a different style. This shot has been taken to fill the frame, but unfortunately included the head of someone walking into the line of vision of the camera. Consequently, the bottom of the picture has been cropped to exclude the person and to emphasize the intensity of the row of houses. It was taken on the zoom at full focal length at 1/125th at f4.5.*

Opposite: *A change of texture – the iron roofing of a railway station. It was taken with the 50 mm lens and the photographer carefully composed the shot to make the four arches frame and balance the picture, as they run along the bottom. On 400 ASA film, at 1/60th, the photographer managed to show up the inner detail of the roof, using an aperture of f4.5.*

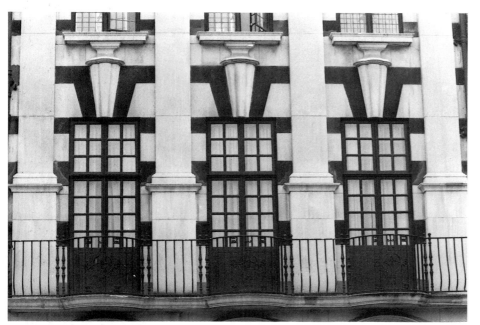

Left: *The strong pattern of verticals and horizontals shot to fill the frame makes this a powerful picture, showing some elaborate details of architectural design. The lines of perspective fall in slightly at the top, as the result of having to shoot up. The open window in the centre top adds interest and gives extra depth to the shot. The light was quite flat, but too much shadow would have confused an already strong picture. It was taken on the 80–200 mm zoom at 1/125th of a second at f5.6.*

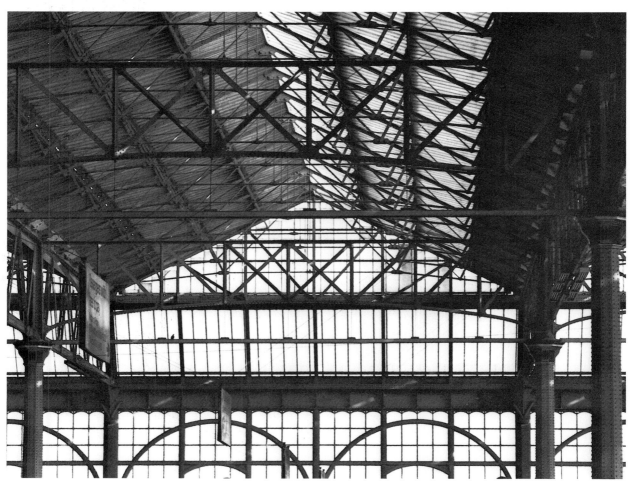

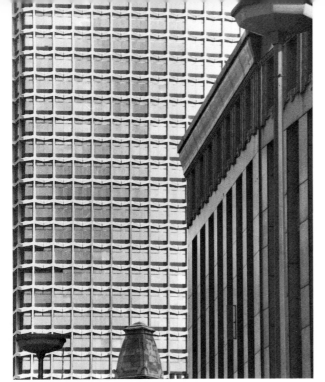

Left: *The juxtaposition of two architectural styles, with one running into the picture and the other across it, reinforces the pattern of both. Although the photographer used the zoom lens from a distance there is still some distortion of perspective, which could have been cropped out, but the sheer size of the larger building compared to the smaller adds to the depth and scale of the photograph. The two lamps also add an element of visual balance and confirm the strength of the vertical lines. The solid structure of the building in the foreground contrasts well with the lighter design and the materials of the skyscraper. Shot on 1/125th of a second at f8.*

Right: *The final picture is of a very modern building of unusual shape and texture, again shot to fill the frame. The shapes on the left of the picture make an equally interesting pattern as they run away from the eye. Disruptive elements, such as the parking sign, add scale and further interest. Used large, this was the most modern example the photographer shot, so it was selected to close the essay. It was taken on the 80–200 mm zoom at 1/125th of a second at f11.*

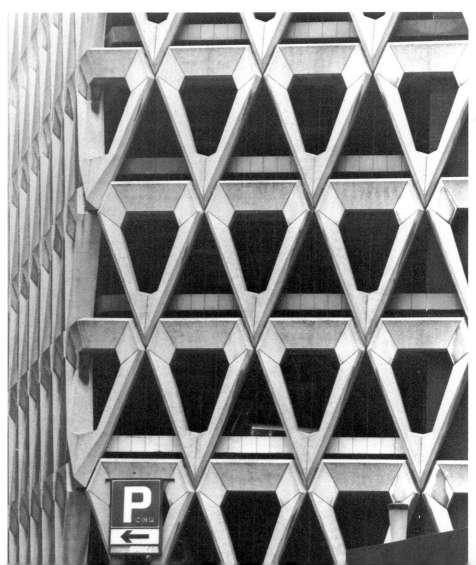

□ □ □ □ □ Project No 3 □ □ □ □ □

Group Activities

Time: one day. Picture essay.

The interaction of people, at work or play, offers the photographer excellent opportunities. Your subject could be anything from a local club on a coach trip to children playing in a park. The aim is not only to capture activity as a whole, but to convey what happens between and within groups, and behind the scenes. This project will increase technical skills by demanding shots of different scale, from overall ones of the whole scene to close-ups of, say, people deep in conversation.

If you choose to cover a local football match, for example, you will first probably need to ask permission to be allowed behind the scenes. Then look for those 'off-stage' moments: a bored child on the sidelines, a disagreement over the score, players' reactions to winning or losing the game. Set up a formal portrait either to start or conclude the essay – perhaps the team with their trophy.

A dance or exercise class makes a good subject. You will have to ask permission, but most people are usually very co-operative, especially if promised a few prints. Capture not only the movement of the class by experimenting with slow shutter speeds, but shoot those off-guard moments: the dancers collapsed against a wall, exhausted, or someone rubbing their ankles to relieve the strain. Look for pattern as all the dancers do the same exercise. If there is a wall mirror, use it to reflect these patterns. Move around, photographing the class at work from different angles, and move yourself up and down as well. Try a shot from the floor, if the dancers are doing an exercise lying down; for contrast, find an elevated position from where you can look down on the class.

Use a variety of distances – from overall shots to middle-distance ones and through to a range of close-ups. Check the light source and use it to highlight the dancers. You may need a fast film if the light is poor; when shooting in colour a tungsten film may be needed if the lighting is artificial, accompanied by a Tiffen FLB filter for fluorescent lighting. Flash will enable you to freeze the action, but you may lose atmosphere and movement in the process. The variation in light and in the tempo of the dancers means that you should bracket your shots and use plenty of film. To vary the atmosphere, try to catch two people in a quiet moment – say, standing talking by a window – and stage a misty, romantic photograph by first breathing on the lens. You will need to work fast before the fog on the lens has cleared. Alternatively, gently smear a spot of Vaseline on a filter (never directly onto the lens) for a similar effect.

This is an ideal project for photographing different age groups. A coach trip of older people would offer excellent photographic opportunities, for instance, so long as you first ask permission. Begin with shots of people arriving and greeting one another, followed by boarding the coach and getting settled in their seats. Try to sit at the front so that you can photograph people talking, reading, and looking out of the window, but do not neglect to take shots from the back of the coach as well – perhaps two heads close together in conversation. Look for faces of character which will make good portraits. Photograph people getting off at the destination and watch their reactions, and follow the group as they look around and explore. You should aim to capture the atmosphere of the day – the initial excitement, the fun of the excursion, and the happy but tired group returning home on the coach.

A local tennis club gives the opportunity to cover sport, spectators, and atmosphere, as does a swimming pool. Such subjects make you move around, learn to deal with people, and anticipate shots, as well as giving you a chance to experiment with lenses, film, and your technical knowledge.

44

The Essays

Two essays have been chosen to illustrate this project, each one quite different in content and approach. The first, by Paul Reeves, follows a local football match between two teams of boy scouts. In variable conditions, it combines action shots with more reflective middle-distance ones, and shows that the photographer had to move quickly to follow the play.

The second essay (see p. 49) by Bryan Alexander captures the mood and movement of a dance class. Taken in colour, it rises to the challenge of using only available indoor light and demonstrates how a professional photographer can produce an essay of pace and balance in often difficult and confined conditions.

Paul Reeves used six rolls of 125 ASA black-and-white film to cover the football match and two lenses – a 28–50 mm zoom and an 80–210 mm zoom – on his 35 mm SLR camera. He kept a 1A Skylight filter on both. Overcast conditions, occasionally brightening up, for the most part allowed fast enough shutter speeds to freeze the action, and middle-range apertures.

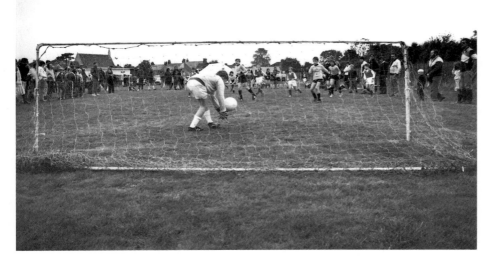

Left: The opening picture of the essay was not the first one taken – in fact it was not even on the first roll – but this wide-angle shot, taken on the 28–50 mm zoom at its widest focal length, uses the goal posts as a frame to the image and leaves the viewer in no doubt as to what the essay is about. To achieve the angle, the photographer knelt down. The speed of 1/125th of a second and aperture of f5.6 have stopped the movement and allowed a reasonable depth of field.

Right: Straight into the action, using the 28–50 mm zoom at a focal length of about 35 mm at f8, this middle-distance shot follows on well from the previous overall view. The speed was set at 1/125th, which stopped most of the action, although there is a slight blur on the hands and feet of the players, but this helps it as an action shot. The sky has been cropped out to allow the players to become an even more dominant focal point.

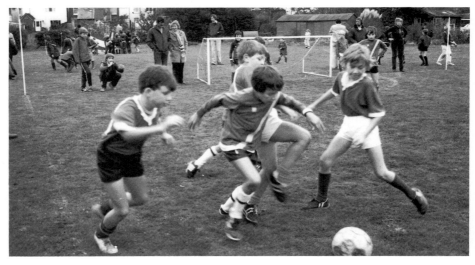

Left: *A quiet moment caught by using the longer 80–210 mm zoom at a focal length of about 100 mm, with the speed set at 1/60th at an aperture of f3.5.*

Below: *The spectators watch the match, unaware of the camera. Unfortunately the top of the head of the man on the right did not fit into the frame and as the photographer was using the 80–210 mm zoom at the time at a focal range of 80 mm, he would have had to move back and so risk people becoming aware of the camera. This and the previous shot add pace to the story, as too many action shots together lack interest. It was taken at 1/60th at f5.6.*

Above: *The bored child on the sidelines makes a good follow-on and takes us away from middle-distance shots, with the 28–50 mm zoom at a focal length of 50 mm at 1/125th at f8. Its simplicity and the absence of other people add to the child's lack of concern with the game and make this a delightful picture.*

Above: *A lovely candid shot at the full 50 mm focal length of the 28–50 mm zoom, the photographer took this in a sequence of shots of the boy when he was evidently feeling the cold. The picture is slightly confused by the legs of other boys appearing behind the main subject, but it is still a worthwhile shot for the moment it catches. The fast speed of 1/250th froze the movement and the aperture was set at f3.5.*

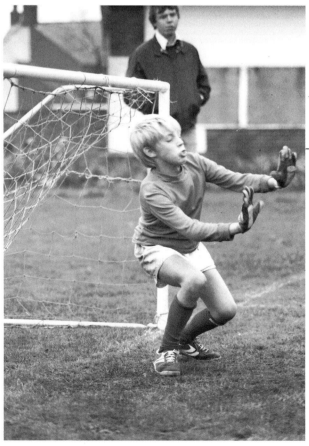

Right: *The 80–210 mm zoom lens enabled the photographer to get in close to catch the movement of the goalkeeper, as a rather bored adult looks on. The fast speed of 1/250th froze the action, and the wide aperture of f3.5 rendered the background out of focus.*

Opposite: *Back to the action, frozen at 1/250th of a second at the wide aperture of f3.5 on the 80–210 mm zoom, giving less depth of field than the wide-angle shots.*

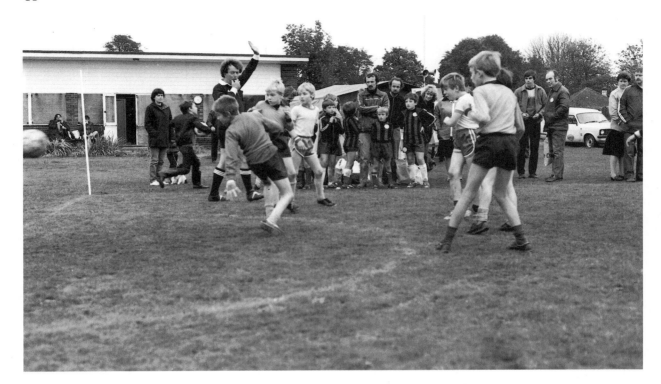

Above: *A goal, or very nearly – although the ball is still moving, the referee is blowing the whistle. This was shot on the 28–50 mm zoom at the widest setting of 28 mm at 1/125th at f5.6. The shot does include some of the spectators, however, which makes it slightly confusing even though it conveys the feeling that the game is 'over'. To end the essay on an unambiguous high point, one further shot was selected.*

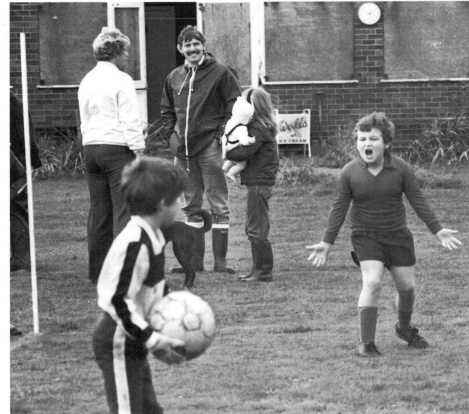

Right: *This picture was cropped to make the angry youngster the focal point of the picture. Shot at 1/125th at f8 at 28 mm on the zoom, it was selected to relate to the previous picture and to bring some emotion to the activities of the essay.*

Another Approach

With the exception of the final shot, Bryan Alexander used 400 ASA colour transparency film to cover the activities of this dance class. As he had to keep out of the way in a fairly confined space, he used four lenses – a 24 mm, a 35–70 mm zoom, an 85 mm, and a 135 mm – to allow a combination of close-up, middle-distance and wide-angle shots of the class and studio. He kept an 81B filter on throughout to warm up the colours of the studio and especially the skin tones of the dancers, and relied entirely on available light.

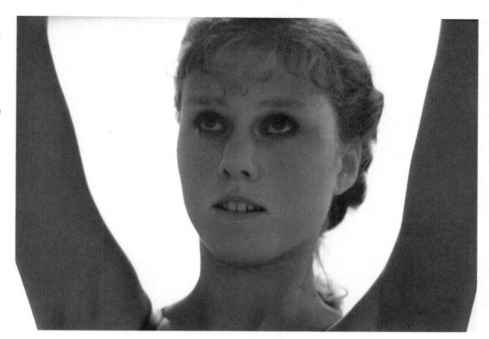

Right: *The first shot, to start the essay, was taken on the 85 mm lens with the speed set at 1/60th of a second and the aperture at f4. The picture 'reads' dance and yet does not show obvious movement. The high-speed film shows some grain which helps the rather romantic atmosphere.*

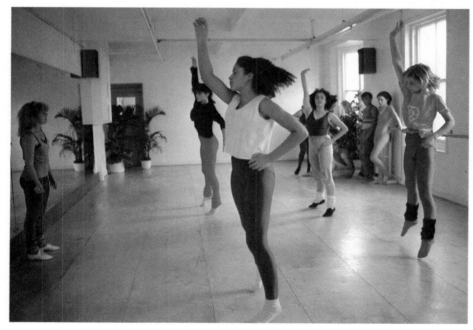

Left: *The second shot explains exactly what is happening in the story, setting the scene by including the large wall-mirror and both the teacher and the dancers. Shot on the 85 mm lens at f4 with the speed at 1/60th of a second.*

Right: *Again using the 85 mm lens at 1/60th at f4, the floor exercise is framed by the plants in the background, which add interest to the shot without distracting from the dancers.*

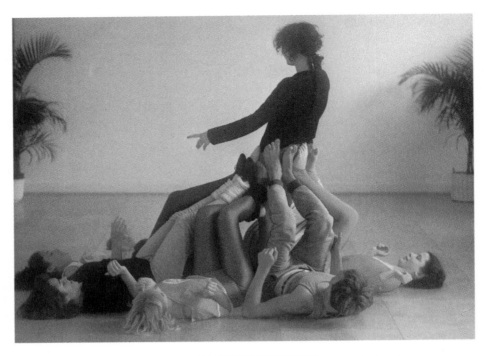

Left: *Using the same 85 mm lens and setting as the two previous shots, the speed is just enough to hold the girls' hair, without ruining the feeling of movement in the exercise.*

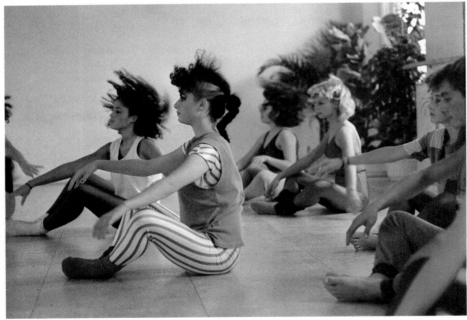

Opposite: *This shot was taken on the 135 mm lens at 1/125th of a second at f2.8. There is little depth of field and the second dancer, who is looking at the camera, is sharper than the dancers in front of and behind her.*

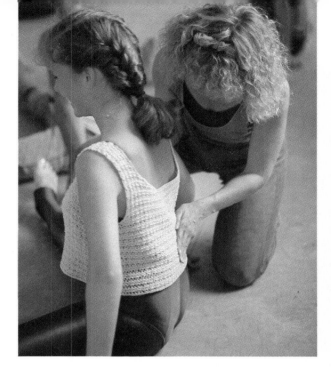

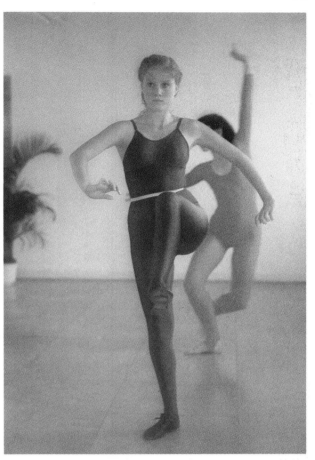

Above: *A close-up of the teacher adjusting a dancer's posture, taken on the 35–70 mm zoom at 1/60th at f4, was selected to show that the essay is about a dance class rather than a performance.*

Right: *Another action shot, but this time full length, taken with the 85 mm lens at 1/60th of a second at f4. The picture adds variety and pace to the essay, as well as being pleasing in its subject and composition.*

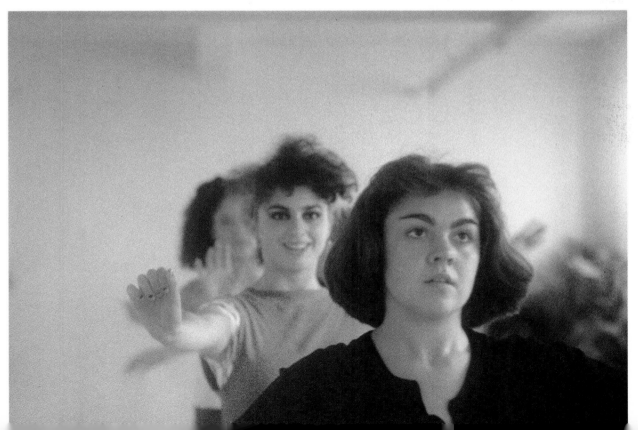

Right: *On the same lens and setting as the previous picture, this shot shows two of the dancers trying out a movement. Other dancers in the background are out of focus, so adding information to the picture while not distracting from the main subject.*

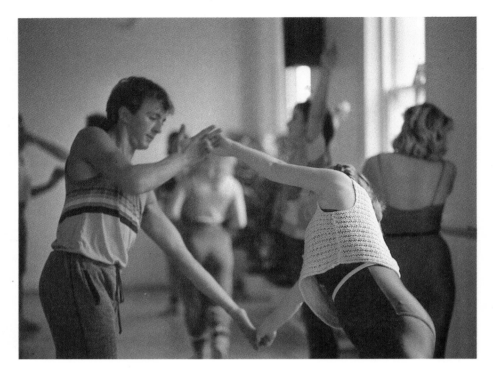

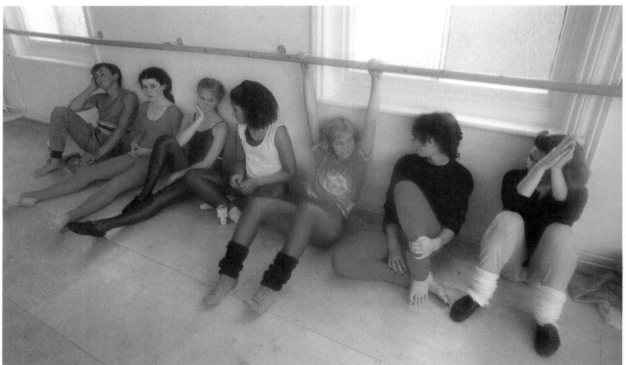

Above: *This final shot, showing the dancers resting after their hard work, was selected to end on a more tranquil note. Taken on a slower speed film of 100 ASA, it mixes with the faster film as its content is very different, although* *normally the two types of film do not go well together. It was shot with the 24 mm lens, smeared with just a touch of glycerine to add to the mood. The speed was set at 1/125th and the aperture at f2.*

Project No 4

Local Industry

Time: two days. Picture essay.

Good photography does not have to be picturesque, although most photographers are attracted to scenes that are pleasing to the eye and tend to ignore the photographic possibilities of what many people consider the ugly architecture of industry. However, such ugliness can be transformed into dramatic images. This project can be approached in a number of ways, depending on the industry of your choice. It does not have to be confined to factories, but might include farming or fishing, or if you live in a village or town, tourism.

Pick one subject within easy reach. You will have to ask permission to enter a premises or visit a farm, for example, but with a bit of charm and professionalism – turning up on time and keeping out of the way, and perhaps sending some prints to people who have been co-operative – you will find some excellent photographic possibilities.

Start with overall shots, taken when the light is most dramatic, usually very early morning or late afternoon, to set the scene of your essay. If, for example, you have chosen a factory or a group of buildings in the countryside, then show them in their surroundings. Move at a distance around the site, shooting from a variety of angles; long shots and wide-angles are particularly useful. Look for highlights on a building and shoot it against the light so that it is all or partly silhouetted on the horizon. Take a shot at dusk, when lights are beginning to come on in the building. You will need a tripod or handy wall, as the exposure will be long. Industrial buildings can look extremely atmospheric in bad weather, so exploit this by using a slow shutter speed to show up the rain or a high-speed film whose graininess will exaggerate the greyness of a building. Shoot through mist or fog to give

an eerie quality to the image. A modern factory with plenty of steel sheeting will provide highlights in almost any weather.

After covering the building from a distance, move in closer and take shots of it to fill the frame, perhaps shooting up from ground level to exaggerate its size. Then start looking for shots of people working, perhaps seen first outside carrying equipment, and then inside, seen through steam, for example, or in the glare of a furnace, or on machines, silhouetted against the light. Explore the patterns and textures of machinery, shot to fill the frame, or use a detail of a piece of machinery as a focal point to your picture, with someone working in the background. Try to use available light to capture the atmosphere of the interior, remembering to mark on the cassette any films that you 'push' to a higher ASA.

Wherever you are, follow the activities from start to finish. A shot of raw materials could make a great opening shot for an essay – with coal or steel, for instance. Look for an angle that gives interesting highlights. Don't forget to shoot the final product, either shot to fill the frame or from a position where you can include the factory in the background. After photographing the factory, find out what time the workers leave and get into a position to take some shots of them all pouring out of the gates; it could make a good final picture to your story. The crowd will appear more dramatic if taken from a distance with a long lens, whereas with a wide-angle lens the factory gates could be used to frame the picture.

If you live in a famous village or town, consider tourism as the subject of an essay. Set the scene with an overall picture of the place, taken perhaps from an elevated position – a nearby hill or tall building, for example. Alternatively, try the other extreme and go for detail with a simple shot of an emblem or plaque that gives a hint as to where the picture was taken and why the place is famous. Look for shots of souvenirs, taken to fill the frame, and of people looking round – reading guide books and maps, buying postcards and local products. Photograph details on packaging,

54

T-shirts, hats, and so on, where a recurring sign, name, or portrait has been used to make those products unique to that place. The whole essay could be one of intrigue, not letting the viewer know exactly where the pictures were taken until the final shot, which then reveals all. Each picture should hint that this is a place important and interesting enough to attract visitors and create a tourist industry, but should not give the game away.

Perhaps you live by the sea and fishing is the local industry. Ask the fishermen to take you on a trip; it will be a marvellous opportunity for some candid and dramatic shots. It might be cold, wet and take all night, but then great photographs were never taken from an armchair. At night, try to exploit the available light from the boat with a fast film rather than relying on flash. If you have to use flash, then find an angle that will diffuse or bounce the light, otherwise you will produce flat and uninteresting shots that convey none of the atmosphere of the trip. Back on shore, photograph every aspect of the fishermen's life, from mending nets and loading up the boats to close-ups of the catch, portraits of the fishermen, and details of their hands at work. You should take a good combination of pictures, although you need not cover everything in strict chronological order. You might not be able to visit the fishmarket, for instance, until several days after the fishing trip, but you should cover the sale of the fish as a natural conclusion to the whole story.

If you pick agriculture as your local industry, you can approach the essay in two ways. The first would be to cover all the different types of farming in your area – arable, dairy, sheep, and so on – by looking for big dramatic pictures where each is very clearly about a single subject. Add impact to your pictures by choosing an unusual angle and interesting light. Photograph a row of dairy cows in the milking shed with a wide-angle lens, for instance, so that the building is included and the cows thus set in context. For arable farming, consider a shot of a combine harvester coming towards the camera, with the corn or barley taken in close-up from the edge of the field, cutting a line across the picture. Have this in focus and the harvester out of focus. For sheep farming, look for appealing angles and light – perhaps photographing the sheep against the light so that it highlights their fleeces. Judge the exposure so that they are not just silhouettes but are easily recognizable.

The second approach to farming would be to concentrate on just one aspect, such as sheep farming or arable farming. Aim for a combination of pictures from dramatic overall shots through to details of brand marks, machinery, portraits of the farmer, farm buildings, and so on. You will thus cover all the things the farmer has to do to run his farm. Try also to convey the season and the particular kinds of work necessary at the time of year you undertake the project. Photograph other people connected with the farm, as well as any working animals such as sheepdogs or ploughing horses. This essay will be more detailed than the first approach and must have a balance of types of shots. It will also introduce the personalities of the people who work on the farm, so be sure to capture their character in your photographs.

The Essay

Tim Jemison's local industry is fishing and that is the subject he successfully shot for this project. He used seven rolls of film, some taken onshore and others out on a fishing trip, and to conclude the story he photographed the fish being sold at market. He took a general rather than specific approach to the subject, covering the most important aspects of a fisherman's work rather than concentrating on one boat and its crew from start to finish. He used three lenses, a 35 mm, a 50 mm, and a 135 mm, on two 35 mm SLR camera bodies. He sometimes 'pushed' the ASA higher to enable him to shoot in poor light and used both 125 and 400 ASA black-and-white film. The selected pictures run as a narrative story, although they were not necessarily shot in sequence.

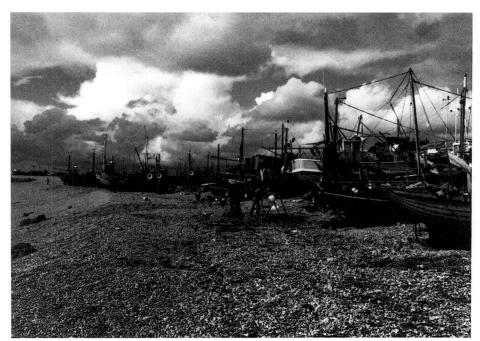

Left: *The first picture, to open the essay, is a dramatic shot that sets the scene. Using an orange filter on the 35 mm lens, the photographer managed to darken the clouds, giving the picture a moody feeling. It was taken at 1/60th at f8.*

Below: *Another scene setter, but this time giving more information by including someone loading up a boat. The buildings on the left and right lead the eye towards the subject. Of the ten pictures taken of the same scene, this one was the most pleasing as the symmetry was right. It was also taken with the 35 mm lens, at 1/250th at f8.*

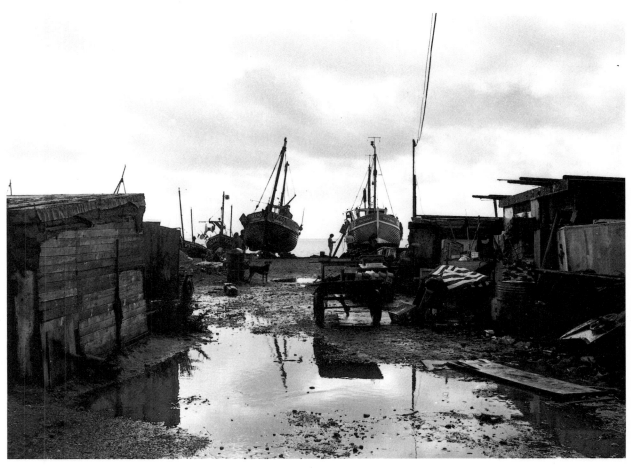

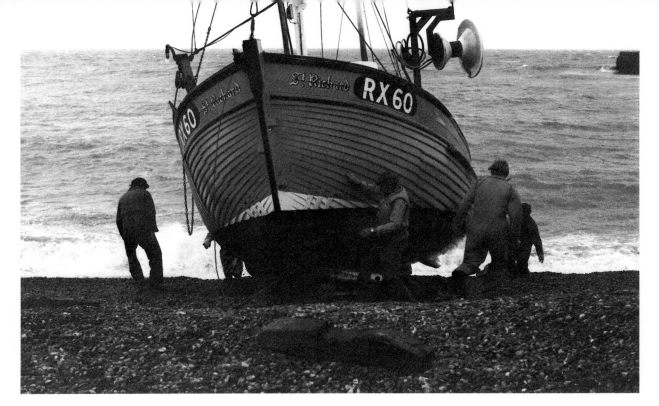

Above: *For this shot, the photographer moved in closer with the 135 mm lens, having uprated the ASA to 3200, allowing a speed of 1/250th at f16. The angle of the men complement the shape of the boat, making the picture both dramatic and pleasing because of its strong focal point. Are the men pushing the boat out or pulling it in? The picture was selected to show the former, as a natural link in the story, but was, in fact, shot as they pulled the boat in – showing how it is possible to use pictures in a different part of the story to their 'truthful' place.*

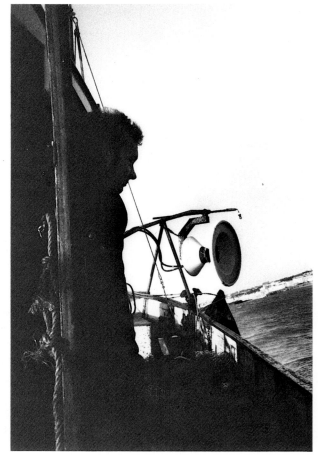

Right: *This shot gets in closer on the subject and follows naturally on from the previous one, telling us that we are now out at sea. While the fisherman is silhouetted, the photographer has managed to keep some highlights on the ropes. Taken with the 50 mm lens, at 3200 ASA at f8, the speed was set at 1/1000th of a second. The upright pole and the outline of the man juxtapose very well with the strange angle of the land.*

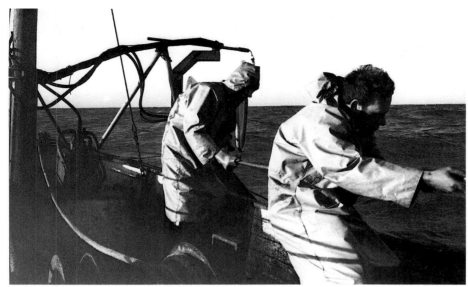

Left: *This shot leads into the real heart of the story – catching fish – and although none have been shown yet, the mind 'reads' this picture as a fishing shot. Taken with the 50 mm lens at f8, the uprated ASA of 3200 allowed a speed of 1/1000th but has also made the jackets of the two men slightly bleached. One of the problems of uprating the ASA is that you cannot revert to the original ASA half-way through the roll of film. In fact 400 ASA film should have been adequate for this shot.*

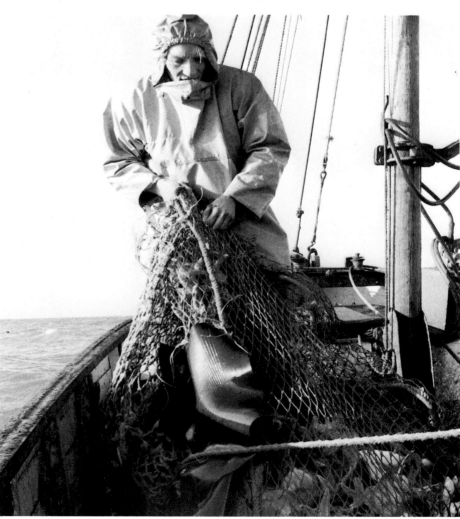

Right: *This picture is an important 'link' shot in the story after the last one of hauling in the nets – at last we see the real subject, fish. As with the previous picture, the jacket of the man is slightly bleached out by over-exposure, although the photographer had to compensate for the darkness of the deck of the boat. It was taken on the 35 mm lens at 1/1000th at f5.6 on the uprated film of 3200 ASA.*

58

Right: *A similar exposure for this lead-on shot, taken on the 50 mm lens, which was on the same roll as the previous shot and so suffers from the same ASA problem. However, it is a useful picture in the story as it shows the catch in detail.*

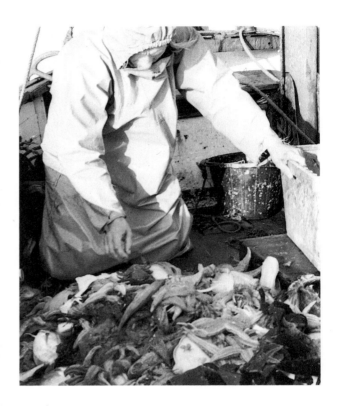

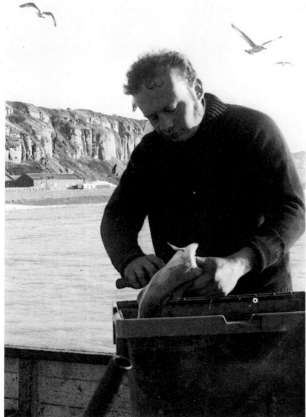

Left: *Gutting the fish, and evidently heading for home with the shore in the background. This shot has a lot of information and is important in the essay as it not only shows us the next stage in the fishing trip, but begins to tell us about what happens to the fish after they are caught. It was taken on the 50 mm lens at 1/1000th at f8, again on 3200 ASA, and has rather too much contrast, but is of good composition.*

If the photographer has so far been on the boat, how did he take this shot? In fact he took it on another occasion, but this picture is both well composed and shows the next step in the essay, that of returning from the trip. As the story is not the photographer's personal account of a fishing trip, however, but a more general story of the fishing industry, one can include pictures taken on different occasions. It is important, of course, to ensure continuity if one decides to cover a specific fishing boat rather than lots of different boats. This shot was taken on the 35 mm lens at f5.6 at 1/100th, again with the ASA at 3200.

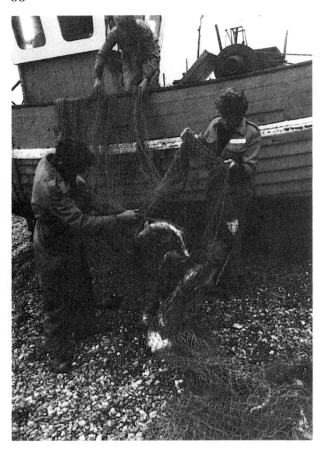

Left: *This was a problem picture when the selection for the essay came to be made. While being the logical next stage in the story and the only one of several shots that showed clearly what was happening, it was nevertheless under-exposed. It was taken on the 135 mm lens at f16 at 1/250th — evidently the photographer took a reading for the middle part of the picture and did not allow for the lack of light on the beach by the boat.*

Right: *A nice candid shot of mending nets taken on the 135 mm lens. Of all the shots of this scene, this was the most pleasing in composition despite the intrusion of an arm on the right. It was taken at f5.6 at 1/1000th on film set at 3200 ASA and clearly indicates that the fishing trip is over, so leading on to the final shot in the essay.*

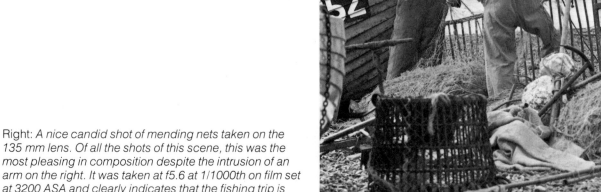

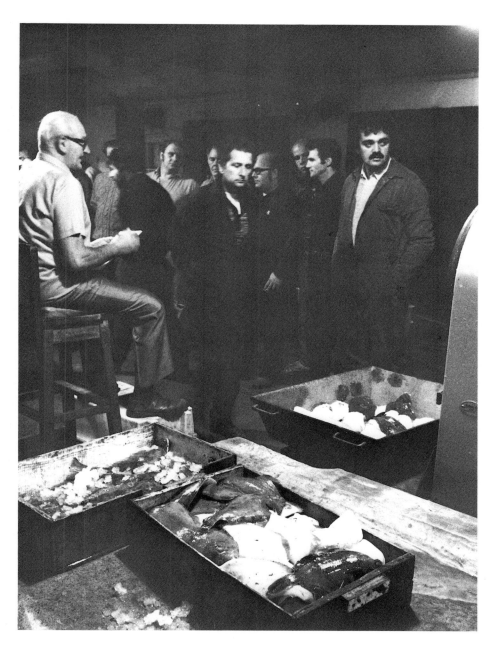

The photographer shot a complete thirty-six frame roll of film at the fish market, using available light, but this was the only picture really to catch the atmosphere and show immediately what is going on. The fish are prominent in the foreground, while the man on the left is clearly the auctioneer. The buyers seem unaware of the camera and are more concerned with the price and weight of the box of fish on the scales. The slight intrusion of the electric light bulb in the top right-hand corner adds to the mood, and the very different setting and lighting conditions compared to the other pictures in the essay, as well as the composition, make this a strong picture on which to finish.

This was one occasion when the uprated ASA did help. The shot was taken on the 35 mm lens at f5.6 at 1/15th of a second and the photographer was fortunate that there was little movement.

Town and Country Animals

Time: two weeks. Picture essay.

A picture essay need not always be a narrative story, a tale of one event from start to finish. It can also comprise a series of pictures in which each picture adds to the story as a whole but without repeating information.

For this project, choose one type of animal in one environment, either town or country, and take as many shots as possible of your choice in as many different situations, while remaining within one or other environment. Over the two weeks allowed this does mean carrying your camera with you as often as possible, as those fleeting moments of a cat in a dustbin, or of a dog crossing at traffic lights, cannot be repeated by setting them up.

The principal choice in town or country is between dogs, cats, and horses. The dogs of the country may include gun dogs, pack hounds, or farm dogs, and the photographs should reflect their environment and their work, and their relationship with their masters. In town, dogs can be seen getting on buses, dragging reluctant owners around the park, or being pampered in a way that country dogs are not. If you go to the park, remember that back views of dog and owner can often be quite humorous; town dogs often seem to resemble their owners.

Cats are elusive creatures, not given to posing for the camera. A long lens can be a useful asset so that you do not have to get too close and thereby frighten them away. They often tend to sit in high, awkward places which lesser mortals cannot get to, so the long lens helps. For country cats, try for shots that indicate their relative freedom compared with their city counterparts. Remember to vary the shots to include some close-up, middle- and long-distance pictures, and experiment with night photography, waiting until the cat is under a light, or by using a flash, or even a torch propped on a wall. You might get some blurred pictures by using a very slow shutter speed, especially if the animal moves, but these may prove extremely atmospheric.

Horses in both town and country offer excellent photographic opportunities — from race meetings and hunts to police horses, carriage horses, and people riding through parks with tall buildings in the background. It may mean having to get up early, as horses are frequently exercised then, but the early morning light will produce more interesting pictures. Try to take some behind-the-scenes shots of horses in their stables, or when they are being groomed and fed.

Experiment with different types of film. Racehorses being exercised early in the morning can look more dramatic if taken on high speed film; the grain will enhance the effect of speed and early morning mist or rain. Horses in a paddock on a beautiful sunny evening would look better on film that conveys the tranquillity of the scene — a slower film with less grain. To give the picture a 'romantic look', try a simple trick of breathing on the lens. It adds a hazy effect associated with summer days. Another way to achieve this is to rub a tiny spot of Vaseline onto a filter (never directly onto the lens).

Once you have made a study of one animal, you could develop the idea to cover a variety of creatures, making their environment the theme threaded through your essay. Try photographing wildlife in the city as a story. Gardens, parks, and cemeteries often have a great variety of species. It is worth doing some research beforehand so that you know what to look for and how to recognize what you see. Another approach would be to concentrate on town birds such as sparrows, starlings, or pigeons; you could mix pictures of these with their counterparts in the countryside.

If you live in the country, a good subject for an essay might be all the animals connected with one farm, or an essay about all the wildlife you can find within a radius of a mile of your home.

Left: *A rather wild-looking cat was selected to open the story, taken on 400 ASA film that was 'pushed' to a higher ASA of 1600. It was photographed with the 90 mm lens at 1/500th to freeze any movement, with the aperture set at f5.6. By filling the frame with the wall and bush, interest is added through different tones and textures.*

The Essay

Using two 35 mm SLR cameras and four lenses – a 35 mm, a 50 mm, a 90 mm, and a 135 mm – Tim Jemison chose to concentrate on town cats for this project and managed, by walking around with cameras at the ready, to find a good variety in different situations. Although a few of the pictures from the four rolls he shot were over-exposed, partly from having to shoot up to the cats on walls and not compensating for the strong light of the sky, and also from having to work very quickly to catch these elusive creatures, there were still more than enough to make up a simple and 'fun' essay.

Like many essays in the book, this does not tell a narrative story but covers a theme in a general way, with a different cat and situation in each picture. All were photographed on 125 ASA and 400 ASA black-and-white film.

Right: *Moving slightly out for the second shot, taken with the 50 mm lens on 125 ASA film, it is the tatty steps that make this picture interesting. To get enough depth of field, it was necessary in the available light to shoot at 1/30th of a second, hand-held, at f8.*

Right: *A longer lens, the 135 mm, was needed to move in close on this cat on a ledge. Taken on 400 ASA film which was 'pushed' to 1600 ASA at 1/250th of a second at f8, the plasterwork surroundings are slightly over-exposed. It should not have been necessary to push the film, but as the photographer had done so in previous shots it was not possible to switch the ASA back half-way through the roll. Luckily the cat is positioned against dark-coloured brick which shows it up well. The simple lines of brickwork and ledge frame the cat, making this a pleasing picture.*

Below: *A good shot for inclusion in a story on town cats, showing the pampered side of town cat life. It was taken on the 90 mm lens at f8 at 1/125th of a second.*

Above left: *Of the twelve shots taken from a variety of angles of this cat, this picture was by far the most appealing as the cat looks alert and about to move. The other pictures, although technically correct, were too static. This was also taken with the 90 mm lens, at f4 at 1/250th of a second.*

Above right: *Although the lines are not perfectly vertical, they help to make this shot attractive. The photographer took several similar pictures, but this was the most interesting as the cat is looking out on the street attentively. The others, taken from some distance over the tops of cars, were more confused images with the subject too far away. It was taken with the 35 mm lens at a slow speed of 1/30th at f5.6. Luckily the cat remained motionless.*

Left: *This shot would have been helped by the use of a polarizing filter to reduce the reflection from the window. It was taken on the roll of film that was 'pushed' to 1600 ASA, with the 35 mm lens set at f8 at 1/250th of a second. It adds interest to the story by including information about the 'human connection'.*

Above: *This was the most successful and appealing of all the pictures of this particular cat. Indeed, it was the most successful subject from the whole shoot, and it is always important to end an essay, however simple in theme, with a strong picture. Shooting from the side has helped to reduce the reflection in the shop window, while the reflection in the clock face is acceptable as it does not distract from the subject. It also helps the pace and balance of an essay to have horizontal pictures interspersed with vertical ones, and this horizontal shot follows the vertical one of the cat on the moped. It was taken on the 90 mm lens at f4 at 1/250th of a second.*

Opposite: *One of eighteen shots of this cat on the seat of a moped, this was chosen as it was the simplest image at the best exposure. Again, the poor light (the area is shaded by a tree, not seen in the picture) caused the photographer to use a speed of 1/30th of a second at f5.6 on the 35 mm lens.*

Project No 6

A Craftsman at Work

Time: one day or half a day. Picture essay.

Some research is required before embarking on this project, unless you already know someone with a talent for making things. Ask around your area for a craftsman or studio producing something that requires traditional skills. You could decide to visit a potter, weaver, or carpenter, for example, or a studio producing furniture, musical instruments, or stained glass. Go and talk to them and explain that if possible you would like to photograph them at work. Most people are perfectly willing to help providing you do not disrupt them. Remember, however, to be professional; work out how long you will need and arrange a firm time and date to return.

Use your introductory visit to assess the lighting conditions. Where does the light come from? Would it be better to shoot in the morning or afternoon? Is there fluorescent lighting? If so, you will need tungsten film and a Tiffen FLB filter for shooting in colour. Would the essay be better in colour or black and white? Will a tripod or flash unit be needed? What speed film would be best for the lighting conditions? Will a long lens be of any use in a small studio?

Ask about the processes involved in the craft and the work likely to be in progress on the day of your visit. Make sure you understand what the craftsmen are doing and in what order, from raw materials to finished product. This is most important, first because you need to know the chronological order of the processes in order to cover them all, and secondly because an understanding of them will enable you to compose your shots correctly and emphasize the right things.

Write out a shooting script of each process, noting possible types of shots — wide-angle of the whole studio, close-up of tools needed, for example — so that when you return you should already have a good idea of what your assignment involves. You will have assessed the lighting conditions and chosen equipment accordingly, and you will have thought through the craftsman's work and how you intend to approach it. This will save valuable time and allow you to concentrate on the subject and cover every aspect of the story. As you have a script to follow you will have more confidence that you will cover everything, which will give you time to look for those sudden, unexpected shots that can turn an ordinary picture essay into a remarkable one. It is not absolutely necessary to shoot the various stages of the craft in chronological order, but a chronological list is the best way to ensure comprehensive coverage.

As an opening picture to the essay you could select a shot of the finished product, with the next shot going back to the beginning of the process, like a flashback. You may have to set up this shot by moving the object to a position that has good lighting and no clutter. Another possible opening would be a close-up of the raw materials or tools needed, or simply the craftsman's hands at work, shot in close-up to fill the frame but not showing exactly what the craftsman is doing and thereby intriguing the viewer. If the craftsman is well known, you might want to feature him as a personality. A possible opening shot would be of him, but set in context — either with a display of his work or against a background of the studio. This will tell the viewer far more than a simple portrait could.

Keep moving around each subject, seeking the best angles and light. Shoot both vertical and horizontal pictures and experiment with different angles and lenses. Use *at least* five rolls of film of thirty-six frames, so that, allowing for a few disasters, you will have enough material to edit down to ten or fifteen good shots. Bracket all your photographs, as indoor light can be difficult to gauge. Above all, take advantage of the variety in any craftman's studio and try to achieve a balance of pictures of objects, people, and setting. Do try the shot

you might be doubtful about. You will not know if it has worked unless you try it, nor will you learn by your mistakes – and achievements.

A final shot to your essay could be a formal pose of the maker and his finished work or a shot of the product itself – providing it has not been used as an opening picture. It could be a shot of a collection of products, all slightly different by design or especially because they are handmade – glassware and pottery are particularly suited to this. If the craftsman is working on something that takes a great deal of time to complete, or needs a great deal of precision work, try to capture that in your pictures. Perhaps a violin-maker, testing the sound, but looking dissatisfied. Capture on film the adjustments he makes and his expression on testing the instrument a second time. Such pictures could be printed up small as a page of pictures within the essay, perhaps before a final shot of the finished work.

The Essay

Using only available light, Leila Kooros photographed the studio of a stained glass company. Although in one morning she was unable to cover the making of one complete piece, she managed to convey the processes involved, the skill and concentration of the craftsmen, and the working materials. Using two 35 mm SLR cameras, one with a standard 50 mm lens and the other with a 28 mm lens, she covered the subject comprehensively. Part of the studio had artificial lighting, so she used tungsten film which helped the colour balance. The rest of the pictures were taken on 400 ASA colour transparency film and there was enough light to hand-hold the camera, at speeds of 1/60th and 1/125th of a second.

Right: This shot was set up by the photographer, who asked for a piece of sheet glass to be pulled out of the rack at the end near the window, so getting the benefit of the sunlight behind the blue glass and the row of racks to lead the eye towards the subject. Taken on the 50 mm lens at 1/60th of a second, the aperture was set on f2 to a reading taken from pointing the camera down.

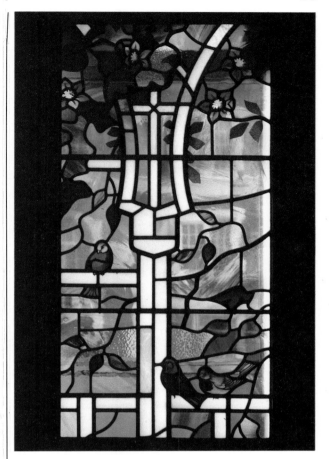

Above: *The first picture makes the subject of the essay immediately apparent to the viewer. Taken on 400 ASA film at f8 at 1/125th on the 50 mm lens.*

Left: *The pattern and glass are laid on a light-box to enable the cutter to see what he is doing. This close-up, which balances well with the wider previous shot, leads us chronologically on in the story, although it is not the same blue glass as seen in the previous picture. The close-up allows us to see the delicate skill required to cut the glass to shape, as well as showing the pattern and the knife. It was shot on the 50 mm lens at 1/125th at f8.*

Right: *This picture shows how the pieces of glass form a larger pattern – at this stage they are held in place by Plasticine on a glass backing. Taken on the 50 mm lens again at 1/125th at f5.6, it shows up the colours and balances well in the essay as it introduces a further stage of the craft, yet has no one in the picture. Although the essay is called 'A Craftsman at Work', it is important to have occasional shots of a quieter nature, and this can be achieved by including shots without people.*

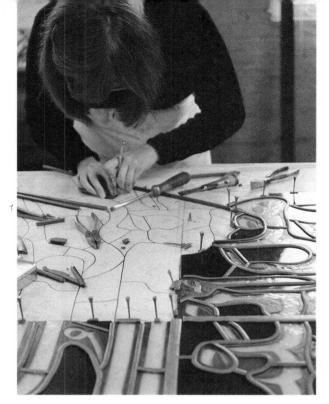

Left: *A vertical shot to include as much of the work as possible. Lack of light has forced a wide aperture of f2 on the 50 mm lens, which has made the foreground out of focus. The speed was set at 1/60th — only just fast enough to freeze a moment of concentrated work.*

Below: *The 28 mm lens was used to include the whole of a large frame into which segments of stained glass are fitted. There was a mixture of artificial and natural light, so the photographer used tungsten film. The wide-angle lens has allowed a good depth of field and the reasonable amount of light gave an aperture of f8 at 1/125th of a second.*

Below: *This still life shows the materials needed for the next stage. Like the previous shot, it was taken on tungsten film to balance distortion of colour from the artificial light, and its simple composition makes the viewer wonder what the materials are used for and so leads on to the next picture. This close-up was taken on the standard 50 mm lens at a speed of 1/125th with the aperture right open at f2, because there was so little light, but the result is highly atmospheric.*

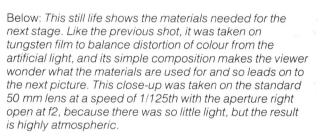

Right: *The wide-angle 28 mm lens was chosen to show what the materials in the previous picture are used for — for setting the lead, which is then powdered to help it dry and finally brushed off. The picture is quite grainy, due to the fast 640 ASA tungsten film. The speed was set at 1/60th at f2.8.*

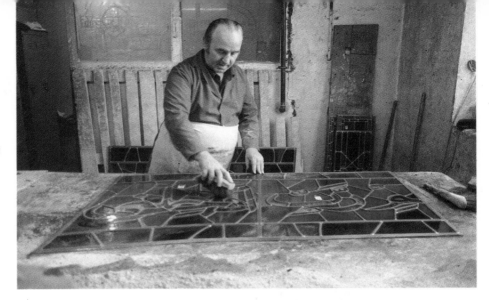

Left: *This still life was chosen to end the essay because it so attractively sums up the atmosphere of the story. Using available light, with the good fortune of the sun streaming through the window, the tools of the trade and the part-finished piece of glass on the left remind the viewer of all that has come before. The picture was taken on the 50 mm lens at 1/125th at f5.6. The rays of the sun, although at a more acute angle than the easel, help to make the composition more appealing.*

□ □ □ □ □ Project No 7 □ □ □ □ □

Take One Tree

Time: one day or one year. Picture essay.

A simple assignment to shoot, but one that will heighten your awareness of shape and light. Choose one tree, without too much around it to distract from its shape, and then photograph it in one or more of the following ways.

The first approach is to photograph it from the same position, with the same lens and film, over the course of one day. This could be in colour or black and white, as both will reveal the changing quality of the light during the course of the day. Consider the position carefully, choosing one that shows both the shape of the tree, perhaps silhouetted against the early morning light, and its scale – you could include a bench or signpost to do this. Having selected your position, mark it with chalk or a stick and take your first shots at dawn. You will need a tripod if using a slow-speed film, so note the height of the camera and shoot all your pictures from that height whether or not you dispense with the tripod later in the day. The light changes very rapidly in the early morning, so check the light meter frequently and bracket your shots.

Return to your position every couple of hours and take more pictures, keeping your camera always either vertical or horizontal – whichever suits the composition better. As the day wears on the brighter light will highlight different parts of the tree and change the early morning blue-black colours to various shades of green and brown. These gradual changes will be recorded as changes of tone on black-and-white film. There will be less evident changes in light from late morning to early afternoon, but later when you come to inspect your prints you will be able to analyse even the most subtle differences in the quality of the light and its effect on shape, tone, and texture. Keep going back to the tree until nightfall, and then take a time exposure picture with the camera on the tripod; with luck, the moonlight will introduce an interesting and eerie quality.

Select a series of, say, twelve of the best shots, each one taken at a different time of day, and print them up quite small. Put in order and frame together as one picture, making a study of light, shape, texture, and time.

A second approach would also involve conveying the feeling of time passing, but in a more pronounced way, and could again be mounted as one picture. Photograph the tree once a month over a year, again from the same position, with one lens and one type of film. Do bracket all your shots so that you can eventually select a balanced set. The aim of this approach would be to show the different weather conditions, the changing colours of leaves and bark, the bareness of winter, and the varying quality of light over the year.

A third approach would be to use different lenses and to move around the tree, studying it from as many angles as possible, but still keeping all of the tree in your pictures. The distance could vary, but do not get closer than a shot where the tree fills the whole frame. Try to find an elevated position – a nearby building perhaps – from which to shoot across and down on to the tree, or take a worm's-eye view, shooting up to the tree with a wide-angle lens. Take at least fifteen shots, each one from a different position or with a different lens.

Another way to treat this assignment would be to start with a picture of the whole tree and then move in closer to concentrate on detail — the shape of the branches, the texture of the bark, the details of leaves and fruit, the insects and birds that may live in the tree. For a mosaic, the first overall shot could be mounted as a large central picture, with the details placed around it. Alternatively, the mosaic could be a progressive sequence, starting with the tree in the distance and gradually getting closer with every shot, finishing with an extreme close-up of, say, a leaf or branch.

Shadows and Silhouettes

Time: one month. Picture essay or mosaic.

Concentrate on one or the other: although shadows and silhouettes are both good subjects for a picture essay or mosaic, they do not mix particularly well.

Shadows

Shadows outside are strongest but shortest in the midday sun, but longer, with more colour – blues and purples – in the morning and late afternoon. Photograph either the subject and its shadow, or just the shadow, and look for as much variety as possible: the distortion of the human shape in long shadows, for instance, or pattern in the shadows of gates and railings. Ask some friends to stand in front of a white wall, so that their shadows fall across it, and make them move around or hold hands until you see an interesting shape to photograph. Use the angles of wall to ground to make the shadow change direction – falling first on the ground and then going up the wall.

Another way to approach this project would be to photograph the shadows of things that are easily recognizable by their shape, such as bicycles, animals, or statues. Include a little of the actual object – where the shadow merges with it – and try to shoot down on the shadow. You may need a wide-angle lens to achieve this, but when you see the prints the shadows will look upright and the objects horizontal. Remember to bracket each shot, as the light conditions in this kind of work can be difficult to judge.

This project can be treated as either an essay or mosaic, but you must have a theme whatever your approach. A series of patterns made by shadows would make a good mosaic, whereas recognizable objects could be displayed as an essay with their upright shadows as the 'objects'. While shadows do contain subtle blues, greys, and purples that change with the light, this project can be dramatic when shot in black and white, which emphasizes shape, tone, and texture.

The Mosaic

Opposite: Mark Karras concentrated on bold, graphic images that he found in strong shadows for this project. He used an 80–200 mm zoom on his 35 mm SLR, usually set at a speed of 1/125th of a second with the aperture varying from f5.6 to f11. The result is a mosaic of nine pictures, selected from a total of twenty-five. They were chosen for their simplicity of shape, which is necessary for a mosaic where all the pictures are used small and in close proximity. Some make interesting graphic shapes by showing all or almost all of the source of the shadow; others allow the pattern and interest to come through by including only a little of the object or person the shadow is cast from.

The shadow of the wrought-iron gate shown here was by far the best of several shots of this subject: it has a good depth of field and so produces a strong, clear-cut image, which is very important when approaching a project of this kind. Another important element – strength through repetition – is shown in the shadows of the two benches; had only one bench been included the shot would have been of little interest. Where the subject as well as the shadow has been included the photographer has moved in to allow just enough information about the origin of the shadow without distracting from its power as an image.

The pictures are helped by the different textures and tones of the surfaces and the careful thought behind the angle from which they have been taken, giving a strong if simple composition to each one. As a result, no cropping was necessary on the nine selected, which make an interesting set without being repetitive. All the pictures were taken on 125 ASA black-and-white film.

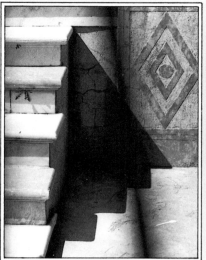
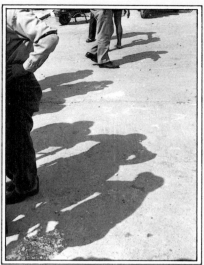
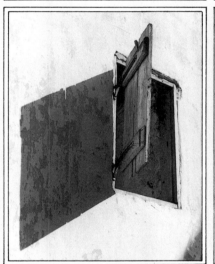

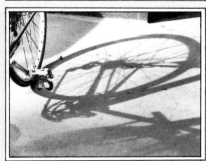
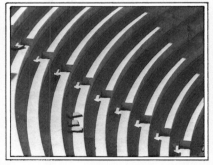

Silhouettes

Silhouettes allow you to concentrate on the most fundamental element of photographs — shape. This project will make you aware of just how important shape is, more so than tone, texture, or pattern; it will help you to think about the composition of your pictures. Many photographers are wary of shooting into the light, but shooting for silhouette is one of the rare occasions when even a strong midday light can be successfully exploited. There are exciting shapes in the tops of buildings, for example, in trees, or even in people walking along the top of a hill. On the flat, create your own horizon by photographing from ground level; include some of the foreground, but keep the subject the dominant factor as a strong shape against the light. The subject will appear black, as a solid, but if you want to include a few highlights then open up the aperture by a stop or two.

It is quite easy to set up your own silhouettes. The simplest way is to place the subject against a window where the light is quite strong. The meter will give a reading for the light coming in and by shooting at that aperture you will create a silhouette. Alternatively, you can place your subject in front of a lamp or stretch a sheet of white or waxed paper on a screen in front of the subject, with the lamp behind both of them. The thinner the material you use for the screen, the stronger the shape will be. The silhouette portrait, so popular with the Victorians, is a good starting point. A series of portraits of your family or friends makes an unusual but fascinating set for framing or for the album.

Try a simple picture story using the screen. Keep it vertical, moving the camera in until the image pleases you. Depending on the strength of the light, you may have to use a tripod. It is a good idea to do so anyway, as it enables you to keep the same proportions of the image in each picture, which is important when shooting a series. Keep your chosen objects simple and easily recognizable in profile by their shape. Start with a profile portrait, for instance, lit from behind. Then take another shot, introducing a table, with your model sitting on a chair. Next, add a teapot, then a cup and saucer. Go on to photograph the model pouring tea, followed perhaps by a shot of the scene, with the introduction of a cat on the floor, which then moves onto the table. Shoot a spilt cup, knocked over, apparently, by the cat, followed by a shot of the model standing up in reaction. A final shot could be of everything on the floor, cat and model gone. Use your imagination to think up similar scenarios, each shot adding a further episode. Write out a short script and include a list of the props you will need. Remember that the story will be most effective if kept simple.

□ □ □ □ □ # Project No 9 □ □ □ □ □

Bad Weather

Time: whenever the weather is bad. Picture essay.

One of the greatest mistakes that photographers make is to believe that sunny days make for better pictures. The midday sun, however, rarely provides interestingly lit subjects, whereas a picture essay shot in pouring rain really does convey how bad the weather is. If you want to photograph the weather properly, you must be prepared to go out and brave it.

Never concentrate *only* on the weather — look for people sheltering from the rain or leaning into the wind, their collars turned up and scarves flying out behind them, or for animals huddled together under a tree. Find a position from which to shoot a sea of umbrellas all glistening in the wet, or fill the frame with the crowd at a tennis match covering up as the heavens open. A shot of people standing in a bus queue is far more interesting if they are all trying to keep the rain off — up go umbrellas and collars, newspapers are held over the head — each person will react in a slightly different way, producing a great photograph. Introduce variety to an essay of this kind by taking a few shots from shelter, of rain beating on a window, for instance, or take cover in an arch or doorway and shoot people hurrying past, using the surrounds of the building to frame the picture.

Remember that a high-speed film shows more grain and so helps to exaggerate rainy conditions, and that black-and-white film is always less distracting than colour. Try experimenting with a slow shutter speed to capture falling rain; it may mean some blur of people rushing past, but can lead to very exciting images.

A variety of waterproof covers are available for cameras and after each session put your camera into one or inside your jacket; remember to wipe the lens with a soft cloth and do so again before you take more shots. A lenshood is particularly useful in wet conditions. On returning home, carefully wipe the whole camera dry with a soft cloth.

If it is very cold, with snow or frost on the ground, be careful when winding on film as it may become brittle and snap. Condensation can also be a problem, so when you take your equipment back into the warm do not open the camera or remove the lens until all the moisture has evaporated. Taking it outside before it is dry will result in surplus moisture freezing onto the camera. In very cold conditions use gloves to handle your camera or your skin may stick to the metal, and protect your face by covering any parts of the camera that may touch it with adhesive fabric tape. Remember, too, that in the cold your breath freezes and may drift in front of the lens, giving a diffused effect to your pictures; this could, of course, produce some atmospheric shots, if that is what you want.

The key to photographing snowscapes is to give each picture a strong focal point to counterbalance the prevailing whiteness, so compose your shots around an object of bright colour or dark tone and keep the image simple. Too many colours or tones will distract from the focal point and make your image confusing. Calculating the correct exposure in such conditions can often be a problem and frequently results in under-exposed pictures. As snow reflects a lot of light take a close-up reading of a mid-tone detail or average the reading between the snow and a shadow area. If there are no shadows try a variety of shots, closing the aperture by up to three stops. The blueness of the light, caused by excess ultra-violet or by the sky reflected in the snow, can be warmed up by using an ultra-violet filter. This will reduce haze and glare, and so give a sharper image. A polarizing filter will also reduce glare and increase the strength of tones and colours.

Mist and fog can give an eerie atmosphere to photographs, with shapes half-seen in the

distance. Remember again to give each picture a strong focal point, however abstract the image, and to experiment by bracketing all shots and by using a variety of filters. Only by looking at the results will you know how to achieve the effect you want. Also, do try some extreme exposures – they can often produce surprisingly strange images.

Heavy clouds can be made to appear darker and more dramatic by using a yellow or red filter on black-and-white film, and a polarizing filter can help darken any blue sky on both colour and black and white. Storms brewing in the distance can have a strange effect on the landscape, as one area of the sky is very dark and yet bright light may be coming from beside or in front of the storm. Watch for the moment when there is a break in the clouds and the sunlight comes down in blue-grey rays as streaks of light through the darkness. To photograph lightning, put the camera on a tripod and use a cable release to keep the shutter open for the duration of the flash. Turn the speed dial on your camera to B for time exposures.

A really windy day can offer some wonderful photographs. Look for trees being pushed by the wind to a strange angle against the landscape, and use a slow shutter speed of 1/15th or 1/30th of a second to capture the movement of grass or litter as they are blown about. Leaves on the ground often seem to be moving in a spiral in strong wind so try to shoot at an angle that shows this.

People often lean at an acute angle into the wind, which makes an interesting shot when juxtaposed against an upright building. Watch how their clothes sweep out behind them, how they cope with their hats and umbrellas. If the wind is pushing them forwards, people still lean forwards, not backwards, and their clothes and hair will be blown in the same direction. Photograph them so they are walking into your picture, not out of it, and watch for contrasts of angles – for example, the moment they pass someone walking in the opposite direction.

Look out for those candid shots of someone chasing after their hat or a piece of paper, or hanging on to a rail to steady themselves. Photograph shop awnings blowing out, signs swinging, or objects that have fallen over. If you see a scene with a lot of inanimate objects moving because of the wind, shoot on a slow speed to capture them all moving at once. The result could be intriguingly abstract.

□ □ □ □ □ Project No 10 □ □ □ □ □

An Event

Time: variable, depending on the event. Picture essay.

The secret of success with this project is to concentrate on the preparations for an event – the guts of the story – as much as on the event itself. If you decide to visit a dance company, for example, then shoot the hard slog of rehearsals, the dancers in their dressing rooms, making up, the fitting of costumes, setting the stage, organizing the lighting – everything that leads up to the final performance. The performance itself may make a fantastic last shot for an essay, but on its own says very little; it does not tell a story.

Near you, someone will be preparing for an event. It may be the local theatre company, a party, or a wedding. Do your research, picking something that interests you and that you feel you can find a new angle on. It should inspire you to find amusing and dramatic possibilities, instead of the predictable.

Take a town or even village show, for example – an opportunity to capture the character of the place. Find out who the organizer is. Is it the local mayor, or perhaps vicar? Has someone been making masses of jam throughout the year? If so, find her and photograph her with her jars and equipment. If you are sure of your shot, you need not take a great number of pictures, but do make sure that you catch enough angles and poses. Is anyone else famous for making something? When do the preparations for the show start – early morning? Be there at least an hour before so that you can photograph people arriving and setting up stalls. Take some full-frame shots of all the goods on display, and as things get underway take plenty of candid shots with a long lens and then move in close, talking to people and finding out what is going on. Watch for people chatting together, new arrivals greeting friends, people looking at the displays, perhaps picking up items or tasting something and then buying.

Above all, try to capture the atmosphere. Is it all very busy and crowded, or rather peaceful? Are people enjoying themselves, or is there an air of rather tense competition? Is someone well-known opening the show? A formal portrait is essential – but the crowd reaction is more interesting. If there is an 'official walkabout', try to keep ahead of the group so that you do not end up with a lot of back views, but do occasionally look back to what the group has just passed – you may see some amusing reactions.

Overall shots are necessary to set the scene, but make them more vivid with careful composition. Include surroundings but give the picture a focal point – if the eye has to wander over the whole image the picture loses power. Use a row of trees or some fencing to lead the eye towards the focal point of the stalls and crowds, or watch for two people talking and use them as a focal point. The focal point need not be in the dead centre of your picture, but should be in a position that makes it either balance with the rest of the image or completely dominate it. Follow the day through until the very last stand has been dismantled and everyone has gone home. Then stay and take just one more picture – of all the litter left behind.

A wedding may conjure up images of the bride and groom surrounded by family, but the really interesting approach is to cover the preparations that lead up to the big day. The conventional wedding shot on the church steps could make a good opening picture to the essay, but let it lead back in time to all the things that have come before; the story behind the story. Shopping for the dress, buying the ring, the fittings, organizing the catering, rehearsals, the emotions on the morning of the big day, each picture pulling the viewer onto the next. A series of portraits of the guests eating, drinking, and talking at the reception could be inserted as a page of pictures – a mosaic – within the essay. A final shot could

be the bride and groom leaving, or simply the words 'just married' written on their car, or a shot of the parents waving goodbye, full of the mixed emotions of the moment. By taking a variety of overall, middle-distance and close-up shots, your story will have pace and will be a far more exciting set for the album than conventional wedding photographs.

It may be that in your area there is an ancient tradition or ceremony that happens just once a year. Start by asking people who have been in the area a long time, noting the sequence in which things happen and when they begin. Follow up your research in the local library or museum, discovering the origins of the event and comparing notes with what you have been told. People often get confused as to exact arrangements and traditions do change over the years. Try to find out who organizes the event and talk to them about what actually happens. Your initial research will show you are interested and will help you to know the right questions to ask. Find out if you need permission to be there and, of course, whether you are allowed to take pictures at all. Again, your research will help, showing that you are serious about your project. It will also help you to anticipate events, knowing the best place to stand and when to move quickly to a good position for your next shot.

Do include some pictures of the background to the story – it may be based around commemorating a local hero, so find out where he or she lived and photograph the house, or perhaps their statue or gravestone. Take some informal shots of the participants getting ready, as well as details of clothes or objects brought out for the ceremony.

The Essay

Photographer David Osborn got this marvellous quiet story by simply asking if he could take some pictures. He was told that he could providing he stayed out of the way, in one place, as he would be witnessing a very special ceremony – a postulant taking her vows to join a convent. Using only available light, with 400 ASA black-and-white film, and setting the camera on a tripod, he produced a beautiful story with the added intrigue of never seeing the nun's face in the pictures selected here. As he could not move, he used a 28 mm, a 50 mm, and a 135 mm lens on his 35 mm SLR to get a balance of shots. Luckily the light brightened as the ceremony began, allowing a shutter speed of 1/60th – just enough to stop movement. The serenity and seriousness of the occasion is reinforced by the use of black and white.

The first picture is of the Mother General, taken with the 135 mm lens, which sets the viewer in no doubt as to what the story is about. The lack of light necessitated a wide aperture of f2.8 at 1/60th, rendering the nun in the background out of focus, which adds to the atmosphere and intrigue of the story. The Mother General is looking down and slightly away from the camera, as if unaware of it, which conveys the feeling that the viewer is almost intruding on the ceremony.

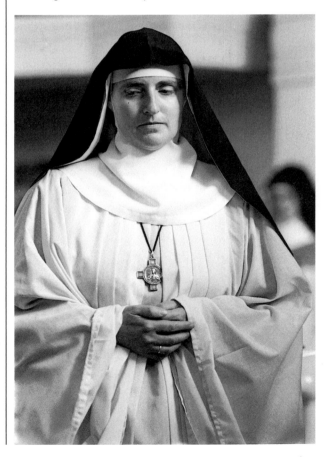

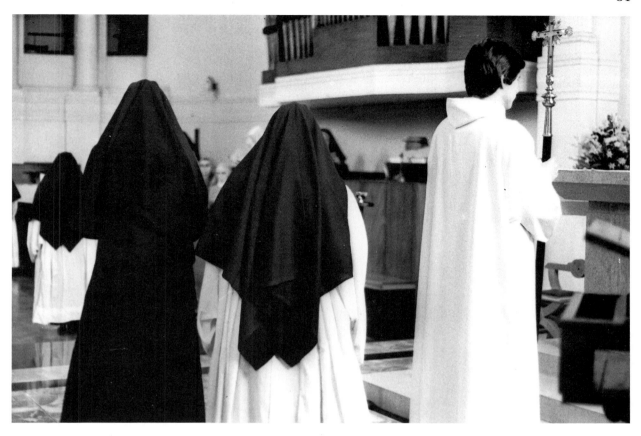

Above: *The young nun (left) is led by the Mother General (centre) into her Perpetual Profession. At this stage the postulant is still dressed in black and it is the first time that she appears in the story – photographed from behind. This approach to the main subject of the essay adds an effective air of mystery. The picture was taken with the 50 mm lens at 1/60th at f1.8.*

Left: *The priest in charge of the ceremony, photographed with the 135 mm lens at 1/60th at f2.8. By shooting slightly up towards him, the photographer has caught the feeling of authority.*

Right: *Using the
135 mm lens again, the
photographer moved in
very close to shoot the
Gospel reading that
announces the beginning
of the ceremony. The
close-up adds balance to
the story and pace, and
due to lack of light the
photographer focused on
the plane of the edge of the
book and the priest's hand.
There is just enough depth
of field to show some type
while leaving the
background out of focus,
so that the Gospel takes on
increased significance.
The aperture was set at f2.8
at a speed of 1/60th of a
second.*

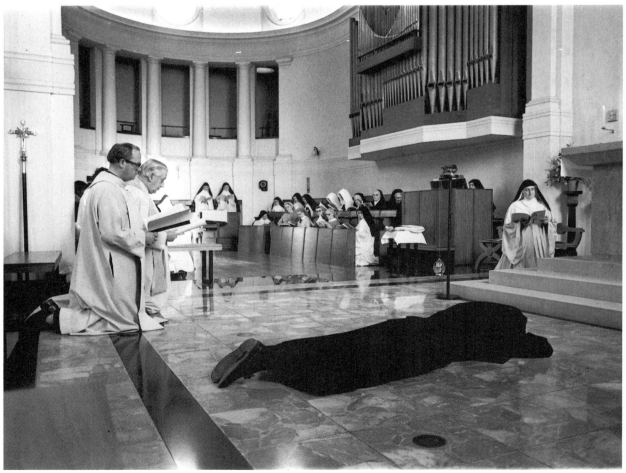

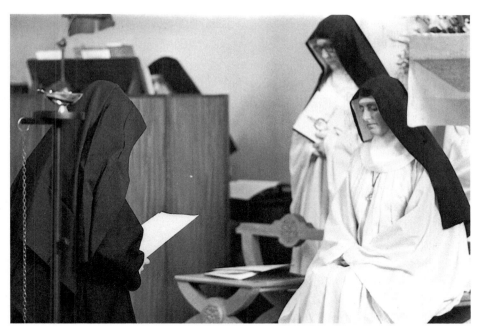

Left: *The Profession – the point of no return – but one still does not see the nun's face. She is made the focal point of this picture not by being in the centre of it, but by being the figure in sharp focus, with the other nuns appearing more out of focus as they get further away. The necessity to expose at f2.8 at 1/60th, so that the black habit is more than just a shape, has meant slight over-exposure of the papers she holds, but they are less important than the nun herself. Taken with the 135 mm lens.*

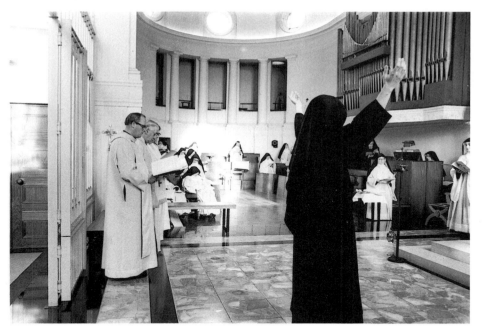

Left: *Back to the 28 mm wide-angle lens for another overall shot, but this time including the grille behind the new nun, the symbol of the world outside, through which she came but will not leave. Again her face is hidden, and although the photographer could not move from his allotted position he has managed to catch the moment where she sings to the altar with her hands raised. Luckily her left hand is shown against a plain wall and not against the confusing background of pillars. The wide-angle lens, at f2.8 at 1/60th, has created a good depth of field.*

Opposite: *The wide-angle 28 mm lens allowed the photographer to include the whole scene of the prostration of the postulant before the altar. The other nuns are concentrating on the service and so seem unaware of the camera. Taken at 1/60th at f2.8 and the best of several shots of this moment.*

Above: *In closer still with the 50 mm lens again, this shot shows the symbolic artifacts that play an important part in the ceremony – the handwritten vows, the Crucifix and the container that held the ring that the nun will now always wear. Shot at 1/60th at f2.8 after the ceremony finished.*

Left: *A middle-distance shot follows on, using the 135 mm lens. The new nun, now dressed in white, kisses the other nuns, but still we do not see her face. Exposing for the brightness of the new cowl has meant losing some detail in the black habits of the nuns to the right, but as the new nun is the subject of the story it was more important to set the aperture (f2.8 at 1/60th) for her than for the surrounds.*

Opposite: *The newly professed sister receives her white cowl, a symbol of purity. Her face is buried and the photographer has caught the downcast eyes of the Mother General. This significant moment, shot full length on the 50 mm lens, is given maximum impact by rendering the background out of focus, with the speed set at 1/60th and the aperture at f2.8. Following the previous overall shot, the essay starts to move in closer again.*

Above: *The Profession
ceremony over, the Mother
Prioress leads the sisters to
communion, but which is
the new nun? The repeated
shape of the cowls and the
serenity of the faces,
unaware of the camera,
capture the mood, and the
intrigue is maintained by
not knowing who the new
sister is. Shot on the
135 mm lens at 1/60th at
f2.8, the light picks up the
whiteness of one cowl,
giving it a translucent,
mysterious glow.*

Right: *A shot of the priest
celebrating communion
after the ceremony, again
taken with the 135 mm lens,
gives an air of finality to the
story. Shot at 1/60th at f2.8.*

□ □ □ □ □ Project No 11 □ □ □ □ □ □

Windows and Doors

Time: one month. Mosaic.

The German Tourist Office once produced a poster that simply consisted of colour photographs of sixteen doors. It seemed an unusual choice of subject to advertise a country, but in fact the poster had enormous visual impact, catching the eye faster than any pretty landscape or townscape. The doors were a fascinating study of design, each one a different colour and with different features. Something that we take so much for granted can, when studied in this way, show how different countries are. One would not find such doors in America or Italy.

The aim of this project is to produce a similar set of pictures, showing the colours, shapes, and designs of either doors or windows in your area. By having to find at least sixteen examples that are interesting in their own right, yet differ from the others you photograph, you will begin to notice architectural details and variations in colour, even within the same colour spectrum. It is not a difficult project to photograph, so you will be able to spend time considering the direction of the light, the type of colour film that would be most suitable, and the position you are going to shoot from. Try to use only one type of colour film, so that your set has a balance of colour and grain. A slow-speed film of 64 or 100 ASA is advisable, as it will enhance the detail and give livelier colour.

Fill the frame with each image, concentrating first on doors for one set and on windows for a second set. Position yourself so that you can photograph straight on, but with enough distance to stop the door or window appearing narrower at the top. A long lens can help if, for example, the door is at the top of a flight of stairs, but you should be able to find enough examples to photograph with a normal camera lens of 50 mm or 55 mm. If you cannot find a position where you can fill the frame without converging lines of perspective, move away from the subject and shoot square on from a distance, and crop into the image on the print.

When photographing the set on windows, look not only for outside architectural details of interest and variety, but for different patterns and textures in curtains or blinds. You could expand on this by including a detail that creates further interest, such as a plant on the window-sill or a cat looking out, but if you choose to treat the project in this way then find that extra detail in all your pictures. Again, fill the viewfinder with the subject and keep the surrounds of the window at the edge of the picture to act as a frame. Glare and reflection can be eliminated with a polarizing filter, which will enable you to include the view beyond the window in your shot. An ultra-violet filter will help to cut out haze and to make the colours appear purer.

The secret of this project is careful composition; frame each picture sympathetically to the subject. For a mosaic, the pictures do not all have to be either vertical or horizontal, but they must reflect the shape of the subject. Photograph all your examples in colour and find at least sixteen different doors and sixteen different windows. You may be able to keep them all in your set, but if not, you will still have enough from which to select a good set of nine or twelve.

A Day in the Park

Time: one day. Picture essay.

To cover the whole day, you must get up early and catch the park empty in the early morning light. Good weather helps, as there is bound to be more activity through the day, but don't let bad weather put you off. Mist or rain and snow can make for exciting pictures in the cold, early light, and whatever the weather, someone will be out jogging or walking the dog. Whether you are shooting in colour or black and white, be up and about before the rest of the population. Find, if possible, an elevated position for an overall shot of the area – a wide-angle lens might help, but is not essential. Take a few worm's-eye views by shooting from ground level, as well as general shots of the park before it fills with people. Pick a view that exaggerates the emptiness – perhaps a still swing in the foreground, or moored boats on a pond, or a closed refreshment stand. One of these would make a good opener to your essay.

The shots that follow through the day will show how the park comes gradually to life and the variety of recreation that people enjoy. Take your pictures at a weekend or public holiday, as there is always more going on. A long lens is useful, as people are usually inhibited when photographed at close range, and remember that you can crop into your subject later. A park is a public place and so it is fairly safe to shoot anything you see, but if you plan to sell a picture commercially you must ask permission, especially if it might be used for advertising. Ask after you have taken the shot, or you will have lost the moment.

Vary your pictures as much as possible, using the camera vertically and horizontally, so giving balance and pace to your story. Consider the angle you are shooting from and move yourself into a position that makes your subject the focal point of the composition. Keep each shot simple, carefully considering where you want the subject within the frame. If you try to include too much, the eye will wander all over the picture rather than being led towards a strong focal point.

Cover all the activities you see – the early morning joggers, people walking their dogs, playing tennis or football, having picnics, boating and fishing, riding horses, and the elderly couple sitting quietly on a bench or examining the flowers. Perhaps there is a bandstand; check the times of the next performance and photograph not only the band but the crowd listening.

Use your technical skills to experiment with different effects. If, for example, two people are throwing a Frisbee, stand behind the thrower and focus on him or her, keeping the aperture wide so that the receiver is out of focus and almost abstract in shape. Wait until the receiver reaches out to catch, and then shoot, and try to anticipate the players so that the thrower does not block your view of the receiver. Capture the action with a series of pictures panning with the thrower. Use a slow shutter speed of 1/8th of a second through to a final shot at 1/30th of a second. The slower the shutter speed, the more indistinct and abstract the image. Move yourself up and down, even to the extent of lying on the grass and shooting up so that you silhouette the players' outlines against the sky.

Watch for children on bikes, and pan, swinging your body from the waist, as they go past. Estimate the distance from the camera to the point where they will pass in front of you and preset the focus. Try to shoot against a background with colour and highlights that will spread and streak over the picture, adding to the feeling of speed. A clear blue sky is a poor background to pan against, as there are no lines to blur. Photograph children on swings from the side, panning with them, and from a position where the light is behind them, exposing for the child and not the strong light, unless you want a silhouette. Try setting the camera on a tripod and using a

very slow shutter speed to photograph a roundabout or children coming down a slide.

Exploit all the events of the day. If it starts raining, watch for shots of people rushing for shelter or, say, sitting under umbrellas listening to a concert. Photograph the people who work in the park — gardeners, cleaners, painters, the attendant pushing boats out, people selling refreshments — and don't forget to cover the wildlife. Almost every park holds squirrels and town birds, often tame enough to be shot in close-up — say, feeding on crumbs specially put out for them. Most larger parks have a lake with wildfowl, which will provide an opportunity to experiment with reflections from the water's surface. In spring and early summer you may, if you are lucky,

be able to try a variation on the typical 'newspaper' photograph of a mallard leading her ducklings to water. Bring the shot to life by getting down low for a 'duck's -eye view'.

If you cover enough activities, you will produce a really complete story of that day in that park, each photograph good in its own right but even stronger when shown with others, each adding more information to the essay. Obviously, the pictures you select will make or break the story, but you must have a wide selection to choose from or you will be unlikely to produce an exciting picture essay.

Parks are full of life and colour and of a happy atmosphere. This can best be captured with colour film, but could work well in black and white, where action dominates the scene.

The Essay

This essay, photographed by Mark Karras, was so successful that it presented a problem when editing the five rolls of film from the shoot. It was not difficult to choose what should be included, but it was hard to decide what to leave out. He used 100 ASA colour transparency film and a 35 mm SLR camera with a 50 mm lens and an 80–210 mm zoom, both without filters. The final nine shots were chosen to give an overall impression of the park and to show all the activities that were happening that day, as well as to produce a balanced story with long, middle-distance, and close-up shots. The weather was rather dull in the morning but brightened up at intervals later in the day.

To lead the viewer into the story, a shot of the entrance to the park, including a man walking towards the camera with his dog, was selected. The light coming through the trees picks up the colours of the fallen leaves, which contrast well with the green leaves still on them. The use of the zoom lens at a focal length of 150 mm has rendered both the foreground and the background out of focus. As the area was dark because of the trees, the photographer crouched down, resting his elbow on his knee to steady the lens. At a speed of 1/60th of a second at f4, he used the self-timer to reduce further the possibility of camera shake.

Left: *Getting in closer, the trees on the right balance well in the composition with the boy on the bicycle. Again using the 80–210 mm zoom, the boy is in focus while the girl who just appears between the two trees is not; she adds interest to the picture without distracting from the main subject. The photographer had already set his camera at 1/125th of a second and had to work quickly to set the aperture at f4.*

Right: *A lovely quiet shot showing the wide space of the park with the focal point of a man and his dog, this picture caught a tender moment. Using the zoom lens at a focal range of 150 mm, the photographer framed the picture to cut out anything that would have distracted from his subject. He took several shots before capturing this moment. Using the automatic facility on his camera, the speed was set at 1/75th of a second at f4.*

Left: *A close-up in which the girl playing leap-frog seems unaware of the camera. Shooting at 1/125th to freeze the action, the photographer anticipated the moment of the jump. The weather had brightened by this stage, and using the zoom at its full focal length of 210 mm on f5.6 the result is a colourful, fun picture that adds another dimension to the essay.*

Right: *An absolute gift of a picture for the photographer, which would have been less funny if the people had been facing the camera along with the dog. Shot on the zoom lens at 100 mm focal range at 1/125th of a second at f8.*

Left: *The simplicity of this shot makes it very strong, helped by the vertical posts and the horizontal lines of the tyre. The child, half-hidden, is unaware of the camera as the photographer was some way off, using the zoom to get in close and fill the frame. Again, he used the automatic facility on the camera, which set the aperture at f5.6 at 1/90th of a second on a focal range of 150 mm. The textures and colours of wood, tyre, trees, and the hair of the child are strong enough to hold the interest, while none overpowers the picture.*

Right: *Leading the viewer out once more, this shot of a football match adds information about the activities in the park, as well as bringing cheerful colour and action to the story. It contrasts well with the previous, more reflective picture. Taken on the zoom at the full focal length of 210 mm at 1/250th of a second, with the aperture set at f4.*

Left: *Karate practice in the deep shade of some trees. To get the shot the photographer lay on his stomach, resting his elbows on the ground to steady the camera so that he could shoot on 1/30th at f2 on the 50 mm lens. The result, although slightly under-exposed, is a fine shot for its interesting subject and composition – the man in white contrasting well with his colleagues in black.*

Right: *A shot of a man cycling out of the park, away from the camera, is an appropriate end to the essay and balances well with the opening picture. Again, the photographer crouched down, resting his right elbow on his knee to steady the camera. He used the automatic facility which set the speed at 1/90th at f4 on the zoom at the full focal length of 210mm.*

▭ ▭ ▭ ▭ ▭ Project No 13 ▭ ▭ ▭ ▭ ▭

The Way It Looks Today

Time: one month. Picture essay.

Find an old postcard or photograph of a place near you to use as a point of departure for this essay. It may mean some research: the local library or museum are good starting points. If you can buy or make a copyprint, you can use it for the opening picture of your story. You may be lucky enough to find a series of old postcards of your chosen area, or even a painting. These do not have to be very old, as buildings, transport, and fashion change rapidly in style. Try to find a picture that contains all these elements, so that when you shoot the same scene the contrast will be very evident. An overall shot, re-creating the scene today, could make a good picture with which to finish the story.

With just one picture as reference, concentrate on detail for the bulk of the essay. Examine the old print very carefully and note as many details as possible, then return to the scene and photograph anything that remains, together with all that is new. It could be a minor detail such as a new door on a building, even though the street light beside it remains the same, but everything will add interest. Remember to re-create the original light conditions as accurately as possible; check the light's direction in the old picture and shoot when it falls that way again. This will be much easier, of course, if you can judge the time of year when the original was taken. Take your time and study the scene carefully before you start to shoot: are the paving stones the same, is there a big new building next to an old one seen in your print, has a little tree grown or been cut down? Then compose your shots around all the details. The whole point of this project is to learn how to convey atmosphere, one of the most difficult skills to acquire. It requires careful preparation and attention to detail – to light, weather, season, and all the other things that contribute to the atmosphere of the original.

If you are able to find a series of old photographs or postcards, you could approach the essay by re-creating each one in turn, taking your pictures in similar light and from the same angle. As early photographs were taken on larger format cameras than those in general use today, you may need to include more of the scene than the original so that you can crop in later, but remember to keep the same proportions as the original. If your set of old pictures shows people walking down the street, then include similarly aged people doing the same in modern clothes.

If the original picture or series of pictures were in sepia tone, then try adding a sepia tone to your prints or experiment with hand-colouring. This assignment could make a fascinating small exhibition, especially if held in the area where the original was taken. Do some research in the local library or museum, and complement the pictures with text describing and comparing life then and now. You will produce a simple but intriguing documentary of changes in architecture, transport, design, fashion, and life styles.

Project No 14

Abstract Form

Time: one day. Mosaic.

Art classes are often asked to draw a bicycle which has been turned upside-down. The reason is to get people away from preconceived ideas of what a bicycle looks like – or rather what people think a bicycle looks like – and to encourage them to draw what they actually see. In the same way, with photography, we tend to take for granted the shapes of objects rather than looking at them as possible sources of interesting pictures. This project concentrates on the forms of everyday things at home; it is intended to push your imagination to its limits and increase your awareness of shape, tone, texture, and pattern in those objects that we think we know all about.

The most important point is that whatever you choose, whether an iron, a kitchen implement, even a chair, it should be shot from an angle that turns it into something quite abstract. By looking at an iron, for example, from underneath, it is the shape that gives it away; but photograph it so that its edges are outside the frame and you are left with an abstract detail of something metal with a few lines and holes. Apart from being good fun, keeping the viewer guessing as to the subject of each shot, this project will make you look at the familiar in a new way; something which will help with all your photography.

Choose objects with a variety of textures: wood, perhaps the corner of a chair or a rolling pin; china, perhaps a vase or teacup photographed from above; metal, a spoon shot from the handle end to the convex side or a box of nails taken from above; glass, a long-stemmed glass turned upside-down on a mirror and photographed from above and slightly to one side to include the reflection. There are lots of subjects all around you which with a bit of imagination can be shot from an angle that makes them appear totally new.

Most objects can be photographed with available light or with very simple artificial lighting – perhaps angled to give a strange shadow that helps with the abstraction – but first move the camera or object around to find the most appealing shape. Experiment with the aperture so that parts of the object might be out of focus, so making it even harder to recognize a familiar household possession. Striking images can be made by slicing fruit or vegetables in half and filling the frame with the strange pattern of the cross-section.

Make sure that the background is free from clutter – place a piece of card behind the object or photograph it from above. Be careful not to let your own shadow or that of the camera fall across the object, but do experiment with using the shadow of the object itself to create an interesting repetition of shape. A tripod and cable release are useful for this project, enabling you to use simple lighting and forcing you to think about the right angle. Keep going back to the viewfinder to check the image and fill the frame with it. A slight move up or down, or to one side, will often produce a dramatic change in shape. If you do not have a macro-lens or extension bellows, get in as close as possible to your subject and crop in later.

The Mosaic

Opposite: Professional photographer Bryan Alexander used available daylight to shoot these objects from unusual angles. He used 125 ASA black-and-white film for a clear image and a 50 mm macro lens on his 35 mm SLR to allow close-up work. Some shots have enough information to be fairly easily recognizable while others leave one wondering; and a few have been deliberately cropped to add to the sense of abstraction.

Most of the shots were taken on middle-range apertures at either 1/60th or 1/125th of a second. Those set against dark backgrounds, however, required time exposures.

Early Morning

Time: dawn to about 9 a.m. Picture essay.

Use this project to capture the mood of a certain time. Early morning does mean early; be up and about as the first light is breaking. Whether in town or country, your pictures should show the stillness of the hour, with the cold, bluish light and long shadows that are characteristic of early morning. Do not let bad weather put you off; rain and mist can add to the atmosphere of a picture. You will need to use a fast film or a tripod at first, or a fast wide-angle lens, as it is unlikely that there will be enough light in the first hours of dawn to allow you to hand-hold the camera with a slow-speed film, but it is the quality of the light, not the quantity, that will give your pictures atmosphere. At dawn, with no direct sunlight, colours will be pale and tones will appear soft; the whole scene will have a blue cast. As the sun rises colours become warmer and tones strengthen, and shadows take on definite shape.

In the country, scenes that you pass every day will look far more interesting in this strange light. The quiet village, deserted, with perhaps just one light on in a house, the road glistening, will appear lonely and rather eerie. The distant farmhouse will seem even more isolated. Look at the dew on the grass or the strange effects of early morning mist on distant hills. Watch for first signs of life: rabbits eating in a field, a single car on a distant road, with its lights on, the farmer leaving his house to go to work. Gradually bring the day to life in your pictures, each one introducing a little more activity, but make sure that you take enough overall shots of landscapes so that later you will have a choice of approach for the story. It could be, say, ten shots of different scenes, all quite tranquil, or an account of how the area greets the new day.

The same approach should be tried in cities and towns. Look for deserted places that are normally crowded – street scenes, railway stations, markets, and so on, and use the early morning light to give an almost haunted look to your pictures. After you have taken a variety of overall shots, gradually include signs of the area coming to life. It might be a lone delivery man, someone unlocking the door of a shop, or someone sweeping the street. Cover as many different early morning activities as possible, giving your pictures a strong focal point which emphasizes that as yet there are only one or two people out and about. Remember to check your shots both horizontally and vertically before you actually take them.

If the atmosphere very early in the morning has a magical quality, due to mist or dew, then a selection of views with no build-up of activity, each used large, could also make an excellent essay.

An alternative approach is to concentrate on a specific place that we associate with crowds. It could be the shopping centre, the zoo, or a railway station. If you choose the station, for example, start with shots of its closed doors, deserted platforms, and blank information boards. Gradually include more and more activity in each picture, culminating in a final shot for the essay of crowds of commuters rushing to work. Keep on the move, looking for the best angles, highlights, and composition. Be aware of lines of perspective and use them to enhance your theme. A shot of an empty platform, with the highlighted rails running into the distance and no trains in sight, will powerfully evoke the deserted early morning atmosphere.

The Essay

David Osborn chose a quiet spot in the country for this project and was lucky in finding misty weather. The resulting set of pictures is very atmospheric. He used one 35 mm SLR camera and three lenses – a 28 mm, a 55 mm, and a 135 mm – and took all the shots on 125 ASA black-and-white film. There was not

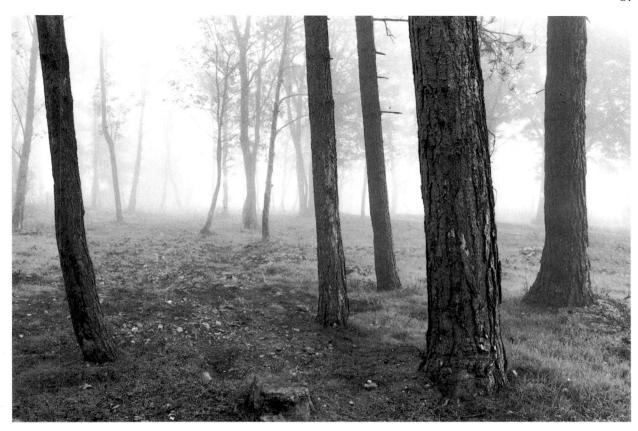

enough light to allow speed settings fast enough to hand-hold the camera in all the pictures, so a tripod was necessary for some. The five pictures in the essay have been selected as 'big' shots to show a variety of early morning scenes rather than tell a story, but from the quality of the light in each shot it is evident that they have all been taken on the same morning – and so the essay has continuity.

Above: Taken with the 28 mm lens, the first shot in the essay sets the scene by conveying the eerie, deserted atmosphere of dawn. The view through the trees is helped by the clarity of those in the foreground, leading us on into the mist. The photographer moved around to find the best composition and took the picture at 1/60th at f8.

Right: The pony in the field appears shrouded in mist, which completely obliterates the background. The photographer used the 135 mm lens to get in close on his subject, with the speed set at 1/60th and the aperture at f5.6. He took several shots of the pony, but this one shows the subject most sympathetically and, as a vertical picture, helps to pace the essay.

Left: *An expansive landscape shot, this was taken in bright, but hazy, light. To get the small aperture of f16 and thereby increase the depth of field, the photographer used a tripod and set the speed at half a second on the 28 mm lens.*

Right: *The photographer had to work quickly to catch this picture of workmen walking towards the camera. It is the only shot in the essay involving people and was selected to finish because it so clearly indicates that the day really is now coming to life: early morning is virtually over. Using the 135 mm lens, at 1/250th at f2.8, the photographer did well to catch the expressions of the men.*

Opposite: *Moving in closer still, with the rushes in the foreground contrasting well with the misty outline of the building behind, so giving the picture a strong focal point. It was taken with the 50 mm lens at 1/125th at f4. This close-up shot adds balance to the other, more general shots in the essay*

□ □ □ □ □ Project No 16 □ □ □ □ □

Communication

Time: one month. Picture essay.

This is a brief to be interpreted as freely as you wish. Communication today is far more complex with the introduction of new technology, but could be treated as simply as a set of pictures of people talking.

Alternatively, you could concentrate on inanimate objects used in communication, from overall shots of radio and television stations to close-ups of, for instance, a street-corner paper stand. With such a free brief, it is important to consider your approach carefully. By limiting yourself to a set subject, you will be forced to go out and look for examples and to consider how best to photograph them to get across the message that these objects are used for communication. When photographing pylons, for example, use a long lens to make them appear compressed, so adding intensity to the picture. Shoot them when the sky is dramatic and the light picks up highlights from the metal. Look for an angle that shows the pylons' size and makes the line of wires run into the distance, so emphasizing that the wires are carrying electricity or telephone messages to far-away places. Use a long lens again to photograph roof-top television aerials from an angle where there appear to be several in a row, as a single aerial does not have the same impact. They will thus make a strong focal point for the picture, especially if silhouetted against the sky. Include part of the roofs to put the aerials in context, as this will help the viewer understand their purpose.

Unusual angles can make a picture more dramatic, so try shooting from ground level up to a signpost or from a height down onto traffic instructions painted on the road. Look for aeroplanes with the company's name painted on the side, and shoot when the light allows you to read it most easily. Watch for smaller aircraft with a message flying out behind on a banner, or writing messages in the sky with smoke. Look at the line up of the cars in a race — they are usually covered in advertising.

Pick a lens and angle that cuts out anything not concerned with the theme of communication, as it will only distract and produce confusion in a picture. If choosing inanimate objects, you could make an essay of, say, ten 'big' shots, printing the pictures large to do justice to the scale of your subject. Another way would be to start with a large object and then move on to smaller and smaller ones. You could begin the essay with a shot of a mass of telegraph poles and their wires, and gradually go down in scale to a close-up of hundreds of papers on a news stand or a shot of several television sets, all showing different channels, in a shop window, or even just the banner headlines of a newspaper.

You may decide to limit yourself to people, or even to children or animals, perhaps concentrating on children with their pets — each will have a different relationship and way of communicating. This essay could be a fascinating study of body language. By concentrating on a single theme your pictures will be stronger in ideas and composition than if you had been shooting at random. Each picture must be powerful in its own right and shot from an angle that shows the scale of the subject — a close-up of children whispering, for instance, or a wide-angle to emphasize the size of a large railway information board. Indeed, if the information board was shot to fill the frame it would merely give you the times of the trains, but a middle-distance shot that includes someone looking up at it will show the board's scale and its purpose.

When photographing people, the less intrusive you are the more chance you have of catching those key moments — it could be gesticulation in anger, a wave to a friend, or a handshake. A long lens is very useful for capturing these candid pictures, but they do call for fast work or the moment will be lost. It is one occasion when you can often get better

pictures by staying in the same place and looking around you. A crowded square, where there are seats, cafés, and people meeting, makes an ideal place for covering communication between people. Find yourself a position where you can see almost all that is happening and where you can watch both benches and café, for example, at the same time. By staying still, with camera loaded and set for available light, you can watch for and learn to anticipate the moments of greeting, discussion, and departure. You can also anticipate, if studying a small group of people, when to shoot an extreme close-up of a handshake, hug, or farewell. Do study the direction of light before choosing your position, making sure that it comes from either the side of or behind the subject, but not from behind you – or your pictures will turn out to be flat and uninteresting.

Try to include people of a variety of ages in your pictures, if you are concentrating on people in general for the essay, as well as a balance of close-up and middle-distance shots. Overall shots work less well in this theme, as unless you can make the subject a strong focal point to your picture it will tend to become lost in the surrounds.

This is an essay that would be very successful in black and white, which will enhance the metallic quality of inanimate objects and the urgency of information. Colour, on the other hand, would be distracting.

The Essays

Two essays – the first by Mark Karras and the second by Leila Kooros – show how this rather 'free' brief can be interpreted. Mark Karras decided to concentrate mainly on people as the theme for his essay and the results show how important it is to think one's approach through carefully when tackling a rather loose theme such as this. He produced some good shots that he would probably otherwise have ignored, had he not already decided on an approach.

Leila Kooros, on the other hand, concentrated for the most part on inanimate objects as the theme of her essay (see p.105), which brought its own problems of lighting and design.

Mark Karras used two rolls of 125 ASA black-and-white film from which six shots were selected for the essay. He carried one 35 mm SLR with an 80–200 mm zoom lens.

The first shot, a magazine stand, starts the essay well by firmly but obliquely hinting at its subject. Although there are no people actually in the picture, their presence is strongly felt in the covers and headlines of the journals. It was shot at a focal length of 150 mm at 1/125th at f8.

Above: *This shot was taken on the zoom at full focal length. A slow speed of 1/60th and a wide aperture of f4.5 were required as the men were sitting under a canopy. The energy of the picture is helped by the man on the right leaning forward, so the three heads are close together, in discussion. Other café pictures in the same series had too much clutter in the background, which distracted from the subject, but this one is helped by a relatively simple background.*

Above: *A lovely picture because of its simplicity of subject and strength of composition – the boy on the left being visually balanced by the boy on the right, with nothing to distract from them. The light was very bright, allowing the aperture to be set at f11 on the 80–200 mm zoom lens with a speed of 1/125th of a second. This shot leads on well from the previous picture, which is closer up and shows faces in profile, and prepares us for the longer-distance shots that complete the essay. This mixture of close-up, middle-distance, and long shots helps to give the essay impact and variety.*

Opposite: *The back view is very neglected in photography, but this one succeeds by allowing us almost to eavesdrop on the conversation. The background does not intrude and the simple composition makes this a strong picture. It was taken at 1/125th at f6 on the 80–200 mm zoom. It is used quite small to give pace to the essay and so that it can be followed by a larger picture, thereby breaking up any visual repetition.*

Right: *A more general view, but another good candid shot. Although the group of people is rather to the left, the picture is balanced in composition by the tree on the right. Taken at a focal length of 150 mm on the zoom, the speed was set at 1/125th at f8.*

Below: *To bring the essay to a close, a quiet moment caught with the zoom at 1/125th at f5.6. It balances the first picture in the essay and contrasts well with the more animated subjects of the previous shot. This picture's strength lies in its simplicity.*

Another Approach

This essay provides a strong contrast with the previous one on the theme of people in communication. By concentrating for the most part on inanimate objects, Leila Kooros was forced to look at the design and composition of her shots, even to set them up, rather than going for the more 'spontaneous', fleeting moments captured by Mark Karras. Using two lenses – a 50 mm and an 80–200 mm zoom – on her 35 mm SLR camera, she managed to shoot at angles that produce interesting shapes while clearly still around one theme. All the pictures were taken on 125 ASA black-and-white film.

Above: *The first shot was, in fact, set up by the photographer and was taken on the 50 mm lens at 1/125th at f8. She almost managed to capture the handshake and its shadow in another shot, but the sun evidently went in. This simple shot is rather apt for the subject: it freezes a symbolic act and its anonymity helps to lead on to the other subjects in the essay.*

Below: *This picture was taken with the 80–200 mm zoom at f11 at a speed of 1/125th of a second and is well-balanced in composition, leading on to the shapes in the pictures that follow.*

Left: *Catching the sun behind the wires makes this a moody picture and yet it still fits into the theme of the essay. It was taken with the 80–200 mm zoom at f5.6 at 1/125th.*

Right: *A more abstract shot, with the wires and spikes running boldly across the picture. Atmospheric and rather sinister, it was taken with the 80–200 mm zoom at 1/125th at f11, and shooting against the light has silhouetted the metal.*

Opposite: *As a final shot, this interesting pattern of telephone lines was selected. It still covers the subject of the essay and makes an appealing picture. The photographer managed to shoot against the light, using the 80–200 mm zoom; and yet keep the detail of the telegraph pole. It was taken at 1/125th of a second at f11.*

Pattern in Nature

Time: one month. At least six shots of different patterns in either landscapes or objects. Mosaic.

Nature is a great designer. The regular shape of a leaf or row of trees are both pleasing to the eye. Even if each tree is a different shape, the fact that they are about the same height and type and are regularly spaced will give a more dramatic effect than just a couple of trees together. Pattern is an important aspect of photography. It brings order out of chaos, which is why we use it for wallpaper and fabrics. Pattern can be created by repetition of shape or by repetition of numbers of the same thing. Pattern in landscape – the arrangement of fields and hedges, hills and valleys – is very dramatic if shot from an aeroplane, but equally good effects can be had from the top of a hill. As long as the shapes are regularly spaced, or have a common colour or tone, or are linked by lines of perspective, they will give the impression of pattern. For this mosaic of images, either concentrate on landscapes or, at the other extreme, investigate design in flowers, leaves, shells, a small area of pebbles, a pattern in sand, and so on. Fill the frame with the pattern, as surroundings tend to distract from the shapes created. As a mosaic, however, images of rows of trees or the layout of fields do not mix well with close-ups of the patterns on leaves or shells.

It is important to remember that tone and line play a vital role in emphasizing pattern. By using a small aperture, the good depth of field will allow the whole scene to be in focus. Good lighting is essential to help bring out the lines and tone of your subject. Shoot in the early morning or late evening, when the shadows are strongest and the light most interesting. Shadow reinforces pattern and makes the image stronger.

With landscape photography, other elements can be added without distracting from the pattern. A shot of a ploughed field from a distance, for example, will look more dramatic if the plough is seen almost completing the pattern it has created. This may mean a long wait for the right moment, but patience is an important part of photography.

A macro-lens or bellows attachment are great assets to close-up photography and would be worth the investment if you intend to do a lot of close-up work. However, if you use a standard 50 mm or a wide-angle lens and get in as close as possible with a small aperture, you can always crop in closer when you print the picture, blowing up the detail of the subject that shows the pattern and design. When shooting a flower, for example, look at it from all angles, taking into account the direction of the light and the colour and tone of the background. You need enough depth of field to have the whole flower in focus. Depending on the light, a tripod would enable you to shoot on a slow shutter speed and thus have a smaller aperture. *(Continued overleaf.)*

The Mosaic

Opposite: Paul Reeves used a 28–50 mm zoom with a macro facility on his 35 mm SLR to photograph these examples of the beautiful colours, textures, and patterns in leaves, pebbles, and bark. Using 100 ASA colour transparency film, the macro facility on his lens enabled him to get in very close, cutting out any distracting background, so it was not necessary to crop the pictures. Although only six were selected to show how he achieved this, the mosaic could have included others as he found many interesting examples.

He also went on to interpret the project in a different way, as pattern in landscape, and produced another set of successful pictures but on a larger scale. The six shown here were chosen for their variety of colour, texture, and type of pattern, as well as for balance, so that no two pictures are too similar although they all follow one simple theme.

Try to take your picture against a background of contrast, either in colour or texture and shape, so that when you blow up the flower on your print any background still visible between the petals or behind the stem does not intrude on the picture.

Insects frequently have the same colouring as the plants they live on, as camouflage, so it is advisable to look for a position that highlights the creature and plays down the plant. If possible, move the insect onto a wall or plant that contrasts in colour and texture. Even if you are using black-and-white film, this will help to show up the shape, texture, and pattern of the subject.

A slow film eliminates grain and gives a better feeling for the texture of a subject. Look for detail in everything, such as the texture of a bird's plumage or the bark of a tree – there is pattern there, too, which close-up work will reveal. If you are lucky enough to find a butterfly that settles in one place for a while, photograph straight down, waiting for the moment that it spreads its wings. Prepare your camera by taking a light reading off similar foliage, so that you can work quickly. You can achieve exciting images by setting up some of the pictures; for example cut a cauliflower in half and photograph the cross-section, keeping the background uncluttered so that the picture concentrates on the shapes. Bring a closed flower into the warm, and photograph it every ten minutes as it opens up, revealing the intricate arrangement of petals. Shoot from both the side and above at each stage. The changes may seem gradual, but they are happening and your pictures will capture them in sequence.

□ □ □ □ □ Project No 18 □ □ □ □ □

Street Art

Time: one month. Picture essay or mosaic.

Every town or city has street art in one form or another and a collection of photographs of one type of street art, or a mixture of several, would make an excellent essay or mosaic. Advertising billboards, wall paintings, shop signs, street performers and artists, and even graffiti appear to be international visuals that either please or offend the eye. This project offers a variety of different approaches. You could concentrate on a single aspect – say, wall paintings – for a mosaic, or on several similar aspects, such as street paintings in general, or you could create an essay on all the various forms of street art.

For a mosaic, you must concentrate on the image; fill the frame with it and crop out most of the background. It is probably best to begin with only one type of street art, finding at least ten to fifteen examples so that you have enough pictures from which to select the best. This may call for some research; ask friends if they have seen anything interesting and check local papers and television for details of any murals that have just been completed, or a new performing artist in your area.

Wall paintings and advertising billboards are often very large and appear to converge at the top if you stand too close. Counteract this by moving away from the subject and shooting with a long-focus lens. Alternatively, photograph from a distance on a normal 50 mm lens or a 35 mm lens and crop the picture later. Shoot square to the subject, so it appears straight on to the lens and has no distortion at top or bottom. Try not to use a very wide-angled lens as although it allows you to photograph a large painting from close-up, the painting will appear distorted.

If you decide to concentrate on street art as graphics and design, look for interesting shop signs, pub signs, mosaics in pavements, or murals in tiles. These are 'designed', but watch also for those images that appear by chance – a poster, half ripped off a wall, revealing layers of old posters beneath, or paint accidentally splashed on a wall. Graffiti can be political, amusing or plain crude, but it is street art. Look for examples that are visually interesting as well as funny or poignant.

Street art can be found in flowers that are designed to grow as a picture, or in topiary. Research any examples of *trompe-l'oeil* in your area, using books and magazines on art and architecture as source material.

As a picture essay this project would work better with one or two disruptive elements to catch the attention, such as onlookers' reactions to a street performer or a child's behaviour when having his portrait painted. Keep your pictures simple, however, and do not include too much, otherwise they will appear confused and the point of the essay will be lost. Look for an angle that eliminates anything superfluous to your subject or render it out of focus by using a wide aperture. Think about composition, choosing an approach that gives your pictures directness and strength. With a billboard, for instance, first study the advertisement and consider what would juxtapose well with it – a colourful van, perhaps, an adjacent advertisement, or a person. Then wait until just the right moment – as, for instance, the right person is walking past – and shoot the scene straight on. The result can often add humour to a picture or make a strong statement about the commercial aspects of advertising.

If someone is having their portrait painted, try shooting over the shoulder of the artist so that you include the artist's hands at work, the painting, and the model. You will need to use a smaller aperture to keep both the painting and the subject in focus.

Street performers would make a good subject for an essay on their own. There should be enough variety among the buskers, tap dancers, jugglers, mime artists, and magic acts on the streets of most large cities. Watch for

those candid shots of people's reactions and try to include both them and the performer in the picture. A long lens can be useful to catch those off-guard moments, while a wide-angle can be helpful if the crowd around forces you to have to work close-up.

Whether you decide to work on an essay or mosaic, this is a colourful subject, so use colour film. The exception is graffiti, which has a 'news' quality – an urgency of getting a message across – and so if concentrating solely on finding examples of 'the writing on the wall', consider using black-and-white film.

The Mosaic

Opposite: Just six examples of street art were selected for this colourful mosaic. Photographer David Osborn included a little of the surrounds in most shots, just enough to make it clear that his subject, wall paintings, is exactly that and not paintings in a gallery. He used 100 ASA colour transparency film, and a 28 mm wide-angle, a 50 mm standard, and a longer 135 mm lens on his 35 mm SLR camera to photograph these examples.

While photographing the wall paintings he was able to take some shots of street performers such as buskers and clowns – a more general approach to the project. On editing the film, however, it became clear that wall paintings as just one form of street art made a powerful and particularly colourful theme, and so shots of other subjects were excluded. This set includes an interesting and amusing *trompe-l'oeil* and makes a useful 'core' of contemporary art that can easily be expanded in the future.

Market Day

Time: one day. Picture essay.

This is a day to be covered from start to finish, as with any picture essay about an event. Get up early and arrive while the market is still deserted, walk round and explore, familiarizing yourself with the area and assessing its possibilities. Later, you will be able to put this to good use when trying to capture the atmosphere of the day. Take a few shots of the empty space which will soon be packed with stalls and people, experimenting with a wide-angle lens and, if possible, with some shots looking down on the area from a nearby vantage point. As traders begin to arrive, photograph them unloading vans, setting up stalls, and chatting to one another. Market day is an ideal opportunity for those who like photographing people and for taking candid shots, as both buyers and sellers are likely to be preoccupied with the goods for sale and so unaware of the camera.

Watch for those moments of calm amid the bustle, someone resting on a bench or a trader reading a newspaper. The traders are often colourful characters and make wonderful portraits. Walk around looking for possible shots with your camera loaded and set for the light available and with the focus preset to four or five metres. If you spot something happening, shoot it right away; wait, and the moment will be lost. Such 'magic moments', so often used in newspapers, may not result in the most technically wonderful pictures, but their spontaneity will more than compensate.

Look at the arrangement of the market and shoot rows of stalls, queues of shoppers, piles of boxes and baskets, and displays of fruit, vegetables, and other goods. Catch moments of concentration – or doubt – as customers make up their minds about a purchase. Shoot close-up and fill the frame: too many general shots will add to the confusion of the situation and make for an unbalanced essay. They will also lack atmosphere. Do not be too ambitious, but aim for a combination of overall, middle-distance and close-up shots, covering all the activities that make up the day. Remember that overall shots must have an interesting focal point – something that holds the attention and does not allow the eye to wander. It could be one stallholder, shouting to the people around him. The energy of the picture will be reinforced by their reactions.

Find interesting displays of goods, unusual objects, and bric-à-brac and fill the frame with them. Watch people buying things – selecting fruit, trying on hats, bargaining with traders, examining antiques – and quietly move into a position where you will get a clear shot without a cluttered background. A wide aperture will make the background appear out of focus and so less distracting, but whether or not there is time to set the aperture and focus the important thing is to shoot right away. A really memorable shot is always worth the risk of an occasional bad one.

Lighting can be a problem, due to the contrast between open areas and those under the shade of stalls. When photographing goods on display, take a reading from the products and allow for any light that may filter in from the surrounds. Strong shadows and highlights can cause even more confusion in an already complex picture, so move to exaggerate one and diminish the other.

It cannot be repeated too often that you must move around and examine all possible angles, and move yourself up and down, too. By simply bending your knee, you may find a much more powerful image in your viewfinder. Bracket your shots and try out compositions both vertically and horizontally before you shoot.

If you manage to find a high vantage point early in the morning, return to it at various stages in the day to capture the contrast between the market at first deserted and then packed with people. Return there again after everyone has done and take another shot – of

all the litter left behind. You could complete the essay with a shot of someone carrying things home – bulging shopping bags, or perhaps a large, awkwardly shaped antique – or even a picture of the cleaners and dustmen.

The Essays

Two photographers tackled this project and the results are very different. Not only did they photograph different markets, but each approached the assignment in a particular way. In the first essay, Paul Reeves covered his market from setting it up until the end of the day and mainly concentrated on long and middle-distance shots. David Osborn's essay (see p. 120), on the other hand, shows that he was far more interested in the people at the market and less in its organization.

Paul Reeves shot four rolls of 125 ASA black-and-white film during the course of his day, mainly using a 28–50 mm and a 70–210 mm zoom lens. He used a 300 mm lens for the first shot in the essay, but this was too long to use around the market. The light was good, allowing speeds of 1/125th and 1/250th of a second – enough to freeze movement. The photographer was therefore able to capture the bustle and activity of the market, but the shoot would have been stronger had it included more close-up shots and more shots of stalls taken from the front rather than the side with the 35 mm SLR.

The crispness of the pictures has been helped by a 1A Skylight filter to reduce haze.

The essay starts with a shot from a vantage point of part of the market, taken with the 300 mm lens at 1/125th at f5.6. Pictures of the whole market area taken from the same position were rejected as from that distance the area looked like a car park, which would have confused the viewer as to the subject of the story. By moving in on one section with the long lens, it is possible to see skeleton stalls and a man moving goods, while the area still appears quite empty. The top of the picture was cropped to make the eye move towards the centre of the picture, rather than wander all over it.

Right: *A pile of boxes, with the head of the stallholder appearing behind the goods on sale, helps to convey the market's transitory atmosphere. If the photographer had moved a few feet to his right, still using the 28–50 mm lens, he could have taken a straight-on shot, with the horizontal lines of the top of the building, the market stand, and the boxes running symmetrically across the picture – all of which would have produced a more pleasing composition. It was taken at a focal range of 35 mm at 1/125th of a second at f5.6.*

Above: *This side shot works well, as it is so deliberate, using the lines of the poles, table, and people to lead the eye into the picture. A focal range of 28 mm on the 28–50 mm zoom at 1/125th at f5.6 has allowed a good depth of field and the shot catches the interest of the shoppers in the jumble of goods on the stall.*

Left: *By moving slightly to the left the photographer would have included the face of the man standing with his arms folded, which would have added interest and balance to the picture and helped to convey the energy of the man demonstrating the vegetable slicer. Using the 28–50 mm zoom at the widest focal range at 1/125th of a second, the picture included an elbow of someone on the right, which has been cropped out. The aperture should have been closed by a stop, as the setting of f5.6 has bleached out some of the detail.*

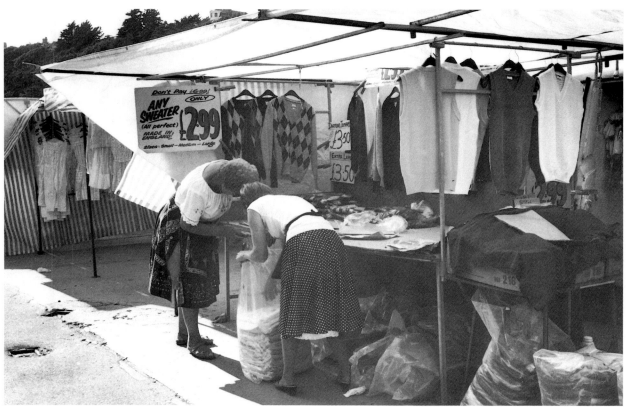

Above: *A good candid shot of two women intent on their business and unaware of the camera, taken on the 28–50 mm zoom at a focal length of about 35 mm. It would have been worth moving quickly for a second shot taken straight on to the stall. The contrast of the bright light and the shade under the stall has meant exposing for the detail of the subject, which at 1/125th at f5.6 has resulted in slight bleaching out of the ground.*

Right: *As the essay was lacking in close-ups of characters, this picture was heavily cropped to concentrate on the man and some of his wares, so setting him in context. Shot at a focal range of 28 mm on the 28–50 mm zoom, the background of the whole picture was too busy and distracted from the subject. The speed was set at 1/125th at an f8 aperture.*

Below: *A quiet moment amid the bustle, but still keeping the subject, a stallholder reading a newspaper, in context. Another wide-angle shot at 28 mm focal length on the 28–50 mm zoom, the speed was set at 1/125th of a second and the aperture at f5.6.*

As a final shot, this picture was cropped on both the left
and right sides to concentrate on the two men who are
rather precariously carrying away empty boxes. While the
market can be seen in the background, people relaxing on
the grass help to add to the feeling of the end of the day.
The picture was also cropped to produce a vertical print
as most of the essay was shot in sympathy with the shape
of the stalls – horizontal. Taken from a distance, the
photographer used the 70–210 mm zoom at a focal length
of about 70 mm, so he could have cropped in to the
subject with the zoom, but might have lost the moment.
The speed was set at 1/250th and the aperture at f3.5.

Another Approach

David Osborn took no overall pictures of his market in this second essay, and few middle-distance ones, but he nevertheless captured the mood of the place and its people. He used 400 ASA black-and-white film and carried two 35 mm SLR cameras and three lenses – a 28 mm, a 50 mm, and a 135 mm, all without filters. It was the 135 mm lens that allowed him to get so close to his characters without disturbing them.

Although a few shots of market stalls have been included, it became clear when editing the essay that the real strength of the shoot lay in the market's people. They have therefore been presented as a separate mosaic in the centre of the essay.

The opening photograph shows some of the objects on a market stall – with the focus of attention on the doll. This tells us that the story is something to do with things, possibly for sale, while not giving away the whole theme of a market. It was taken with the 50 mm lens and needed a slow shutter speed of 1/60th and an aperture of f8 to give some depth of field in quite poor light conditions.

Left: *Showing another aspect of the market – the man on the fruit stall arranges his wares. The distinct angle, taken on the 28 mm lens at 1/60th at f4, helps to introduce variety to the types of shots in the essay.*

Below: *An overall shot of a stall with people looking at the goods for sale sets the scene for the rest of the story. It also adds pace, contrasting well with the previous close-up. It was shot on the standard 50 mm lens at 1/60th at f8.*

It is sometimes useful to introduce a mosaic into an essay, especially when each picture is similar in content, that is, on one subject. In this case, the photographer took a series of good close-ups of the characters he encountered at the market. Each picture adds information, capturing the atmosphere of the scene, and yet does not need to be treated as completely separate from the others, as all have a common theme. They were mainly

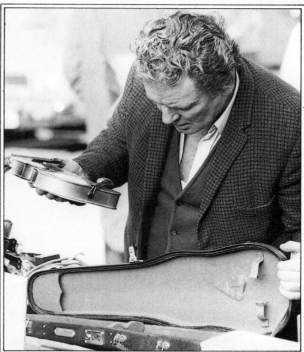

taken on the 135mm lens, which allowed the photographer to get in close on his subjects without making them aware of the camera. The exception is the picture of the two children, which was taken on the

wide-angle 28mm lens at 1/125th at f5.6. The photographer moved down to their level and as he had to get in close with the 28mm the children are aware of the camera, but it remains a charming shot.

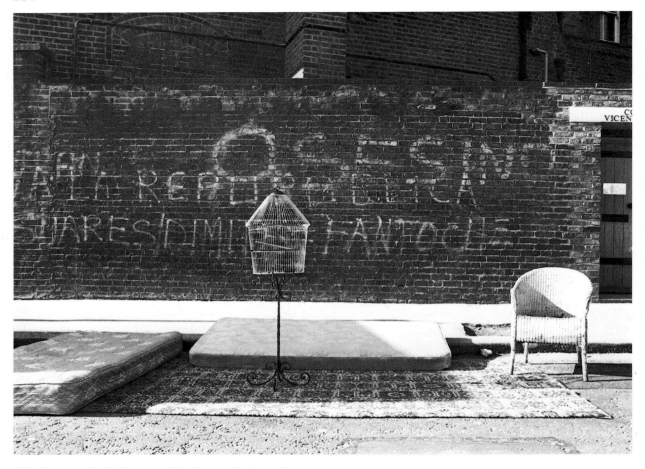

After the mosaic of close-ups, the story ends by moving out again for a final shot of some of the more unusual things for sale. Although on a larger scale than the opening shot of the essay, this nevertheless balances well with it. Like the opening picture, too, this one lacks people, but any abruptness in the ending of the essay is softened by the distinctive composition of the shot. It was taken on the 28 mm lens at 1/125th at f8.

□ □ □ □ □ Project No 20 □ □ □ □ □

Shapes and Symbols

Time: one month. Mosaic.

This project can be treated in two ways. First, in an abstract form – seeing a recurring shape in the things around you. The second is more literal, but still requires a sharp eye.

Choose either a shape or a symbol and photograph it in as many different situations as possible. By concentrating on one recurring subject, your pictures will make a mosaic of repeated patterns or objects with a common theme, but each picture within the mosaic will differ from the others. A shot of a fan shape in the iron railings of a gate says very little on its own. Nine or ten shots of that shape in as many different situations make a striking set of pictures, each one enhancing the others and creating enough variety to make even a simple subject seem fresh and interesting.

Pick one shape or symbol from those listed here, or think of your own, and in either case decide how to expand on it. As you travel around, look for it in everything you see – in architecture, paintings, nature, on signs, and so on. By concentrating on one subject, you will be surprised at how often it appears in places where you would not before have noticed it.

Shapes

The Spiral From staircases to shells, the spiral occurs in many forms. Look for it in architecture, pavement design, graphics, and in nature, in large objects and in small, mixing man-made spirals with those found in nature. Try to find spirals in both two and three dimensions. One shell or one spiral staircase is enough, as it makes the point. The more variety in your examples, the more interesting your set of pictures will be.

The Pyramid You don't have to go to Egypt to see a pyramid. It could be the roof of a building, shot against the light to exaggerate the shape. It could be pile of apples on a market stall, a display of gymnasts forming a human pyramid, or made with playing cards.

The Cross While this is a symbol and could certainly be treated as such, think of it as a shape instead. It could be as simple as a gardening spade and fork lying across each other in the garden, or a road junction photographed from a tall building. It occurs in architecture, on the grand scale as well as in details. Try to avoid the typical Christian cross, as this is an exercise in finding clear-cut shapes where you might not have looked for them before.

The Circle The most immediate choice is the wheel and a set of pictures of nine different types, from cars to bikes to trains, would make a visually exciting mosaic, but the circle appears in many other things. A pile of pipes shot end-on, people with umbrellas shot from above, a bowl of apples, also shot from above, tables in a café, someone wearing round glasses – there are endless possibilities. To emphasize the shape, fill the whole frame with the subject – too much background will be distracting. Look at the light carefully, moving around the subject until the light highlights its form.

The Fan Not actually fans, as it is the shape you are looking for in other forms. Look at the design of a leaf; many are fan-shaped, so fill the frame in a close-up, trying to capture the texture and shooting in light that highlights the shape. Bright light tends to flatten any ridges, so shoot in late afternoon when the sun gives longer shadows. Find the fan shape in architecture and design; many doors and gates have the sunrise/fan design and it appears on many forms of commercial packaging, as well as in carpet and clothes design.

Symbols

Does your town have its own emblem? In Dublin, for example, the Irish Harp can be seen on buildings, clocks, taxis, hats, uniforms, and in sculpture and stained glass. If your town is famous for a product, its symbol might be used on buildings, vehicles, and packaging, too. If the town is well known for someone famous having lived there, look for souvenirs, advertisements, and shop signs that commemorate the fact. Nine or twelve examples all on one theme will make a good page of images.

Animals Throughout history, animals have been used as symbols. It could be the mythical dragon or unicorn, or the wise owl. Lions, cats, dogs, and horses all appear in art and architecture, in advertisements, and in everyday objects – from lamps to boot-scrapers. Photograph either one animal in as many different situations as possible or find at least nine different animals in a variety of situations, but not, for example, all in architecture.

The Sun Another popular symbol, either as a complete circle of red or yellow, or as a half-circle with rays indicating sunrise. It has been used by nations as a symbol on flags and by companies as corporate logos on letterheads, delivery vans, advertising, packaging, and buildings. It was particularly popular with designers in the 1920s and 1930s, and can be found in details of houses of that period such as gates, front doors, and windows, as well as in lamps, handbags, carpets, and on cars.

The Moon and the Stars These have also been used in design through the ages. The moon, either as a circle or crescent (the Turkish emblem, for example), is to be found in a wide variety of places from shop signs to badges. The stars, either singly or in clusters, may be seen on the flag of the United States, for example, or as a symbol of the Jewish religion, and through to packaging design and even ear-rings.

The Female Form This appears in architecture, sculpture, and friezes, in the shape of chairs and teapots, and in small objects such as bottle-openers and pens.

From these suggestions, pick one and shoot all your examples on the same type of film, either all in colour or all in black and white as the two do not mix well; the colour will dominate the black and white. Remember to fill the frame with your subject and by using the same type of film you will keep a balance in the set. It means having your camera with you as often as possible, or noting down a good location so that you can return to it at a later date.

The Mosaic

Opposite: There are a variety of ways to interpret this project and David Osborn chose to concentrate exclusively on animals in sculpture and architecture. In the space of a month he was able to find more than twenty different examples, which he shot using 400 ASA black-and-white film and two 35 mm SLR cameras with three lenses – a 28 mm, a 50 mm, and a 135 mm. Nine shots were selected to make up one page of images, giving a wide variety of different subjects.

Had the photographer decided to concentrate on one animal, it would have been important to include graphics and symbolic shapes as well as sculpture, but he found more than enough different examples for this mosaic and by using different lenses and angles was able to emphasize their size and positions. The gull on the head of the lion gives it scale, as does the angle of the sphinx, which includes just enough background to set it in context without distracting from its shape. In all the shots against the light the aperture was carefully set so as not to produce a silhouette.

The stern-looking bull was photographed with a 135 mm lens as it was high up on a building, but still had to be cropped to bring it up to the scale of the others in the set.

□ □ □ □ □ Project No 21 □ □ □ □ □

Views From a Window

Time: one day or over a year. Mosaic.

Patience is an essential element of the photographer's art, and this project needs a great deal. It *appears* to be a simple exercise, but in fact offers many technical challenges. There are two main ways to approach it.

The first is to choose a window with a good view and where there is going to be plenty of activity. It could overlook a street, or garden with children and wildlife. If necessary, use a polarizing filter to reduce glare from the window-panes, or shoot with the window open. In either case, use the surrounds of the window to frame your pictures – you will have time to compose them carefully – and take a series of shots through the course of one day. Wait for the right moment – a passer-by, a bird in the garden, a child on a swing – and, with the changing light through the day, you will produce a very pleasant set of pictures.

A similar set of pictures could be taken over the course of a year. By shooting the same scene, say, once a month, you will capture the changing colours of skies, plants and buildings, and the quality of light, from season to season.

The second approach is to take pictures from each of the windows of your home, again using the window-frame as a border to your photographs. This can be done in a few hours or over a whole day, or even over a year. Watch the direction of the light and shoot when it adds interesting highlights and shadows to a a subject. If it is raining, focus on the raindrops on the window-pane, so keeping the background slightly out of focus and almost abstract. If the window is steamed up, let it reduce just enough to reveal images outside. Alternatively, for a soft effect, breath on the lens or on the glass pane.

Bad weather produces plenty of exciting opportunities. When it is pouring with rain or very windy, wait until someone hurries past leaning into the wind. Their angle will make an interesting juxtaposition with the upright of the window-frame. If you are looking down onto a street, the tops of umbrellas will produce intriguing patterns and shapes and from the right angle it will look as if there is no one underneath them. Snowflakes and frost add interesting texture, so experiment with shooting through them.

Yet another possibility is to concentrate on an object on or by the window-sill, keeping the background more or less out of focus. Ask someone to model for you, sitting or standing in front of the window and looking out. They will appear silhouetted if you expose purely for the light coming in, so take a reading for the highlights of your model, which will allow for detail to show up. Make sure there is no indoor source of light that may affect your meter reading. Remember to bracket your shots and stick to one lens, preferably a standard 50 mm, shooting either vertically or horizontally in sympathy with the shape of the window-frame.

□ □ □ □ □ **Project No 22** □ □ □ □ □

Primary Colours

Time: one month. Mosaic.

A far more abstract theme than many of the other projects, but one which will make you look for colour as a general idea and heighten your awareness of how simple patches of colour can make exciting visual images.

The three primary colours are red, yellow, and blue, each occupying a third of the visual spectrum. While, for example, reds cover a wide area from crimson to magenta, you should try to concentrate initially on the brightest examples, where the colour dominates the picture.

The most important decision in photography is what to include in a picture. By being very selective and leaving out anything that may distract from the boldness of the chosen colours, your pictures will have greater impact, and this will help you with all your colour work.

There are two ways to approach this project. The first is to chose one of the three primaries and look for it in as many situations as possible, considering the angle and type of lens that will help it to become the dominating feature. The second approach is to look for all three colours, either singly or in any combination, which will give you wider scope. However, if you find a possible shot with two or three of the primaries, shoot from a position where each is as dominant as the other. Keep all your pictures simple to make the colours appear bold.

Look for at least twelve shots for either approach. They could be as simple as a yellow plane in a blue sky, a bright blue door in a brick wall, or a red umbrella in a grey street scene. Watch for things like the bright red sails of a yacht, with the colour reflected off the water to increase its impact; a row of people in bright red or blue uniforms, shot with a long lens to make the line seem compressed and the colour more intense; a box of Christmas decorations, or a coloured streamer hanging from a ceiling; fruit on a market stall, shot to fill the frame; the redness of the sun at sunset, or a large yellow full moon. These are just some suggestions for shots where the colour makes the picture and wins over black and white. Flowers are excellent subjects, with their bold colours and simple shapes, so photograph either in close-up or against surroundings of contrasting colour, texture, and tone.

Most cities are a blaze of colour at night, with neon signs in the brightest colours. Photographed just before it is totally dark, the colour of a neon sign will still dominate a picture, but add interest by showing some details of the setting. You can uprate a fast film to a higher ASA which, used with a wide-aperture lens, will enable you to hand-hold the camera if the scene has a lot of light. Otherwise, use a tripod and cable release to avoid camera shake. Neon lights can be satisfactorily shot on daylight film.

Under-exposing by half or a full stop will increase colour saturation, while over-exposing will weaken the colour. A polarizing filter may help to increase colour strength by reducing glare off flowers and painted surfaces and by deeping the blue of the sky. A soft light is preferable to the harsh midday sunlight, which invariably diminishes the richness of all colours.

Colour is used as a means of communication, claiming one's attention in a way that simple black and white cannot. It is used in signs of all kinds, for instance, traffic signals and emergency services, or in advertising and national flags, often to the extent that it becomes a 'code' of its own. This aspect makes an excellent subject for a series of pictures – look for primary colours in signs, packaging, posters and badges, and so on, and compose your shots so that the colour is the focal point and dominating factor.

Alternatively, try to capture colour in movement. If you see someone running in a

bright blue jogging suit, for instance, shoot on a very slow shutter speed and pan with the subject so that the colour becomes a blur, streaking across the picture. Any colour in the background will lose its shape and identity and becomed blurred too. This approach has virtually endless possibilities, from a fast pan with, say, a bright red car speeding past to a yellow canoe on a fast stream, but make sure that the colour remains the focal point.

While you can set up some of the shots for this project, you will need to have your camera with you as often as possible. Return to subjects that you have shot after a few days, or even months, and see how the light has altered the impact of their colours. Photographing in colour can, however, lead to confusing pictures, so treat this project as a lesson in how to be selective and how to use colour effectively to make bold statements.

□ □ □ □ □ Project No 23 □ □ □ □ □ □

A Day in the Life

Time: one day. Picture essay.

Ask a friend or member of your family or even a stranger if you can photograph their day. It need not be a special day – the most routine one can offer excellent photographic possibilities. It can be an advantage to photograph someone you know, as they will be more at ease, but on the other hand strangers are likely to get on with what they were going to do rather than talk to you all the time. Also, if photographing someone you don't know, you are more likely to notice their mannerisms. This project could follow the day of two people, or indeed of an animal, such as a family dog or riding-school pony.

Almost anyone you choose to photograph is likely to be aware of the camera at first, but will soon relax and carry on with their work. A long lens can be helpful on such occasions, enabling you to photograph unobtrusively. Watch for moments during the day that reveal character – is your subject very serious most of the time or does he or she laugh a lot? If covering a working day, try to make your pictures show all the aspects of the person's job, as well as whether it is hard work, whether they enjoy it, and so on.

Life photographer Eliot Elisofon once said: 'You don't have to try and be a candid photographer, hiding in the bush. Just seat your wife in the garden, for example, talking to someone. Let her forget the camera. Don't get too bossy or too close.' By having to cover a full day, you will learn to be unobtrusive and to deal with people, making them feel at ease, as well as teaching yourself to work quickly and watch for those magic moments that make good photographs great. It will also show how good pictures can come from seemingly ordinary situations. It does require some stamina to keep going until the end of the day,

but is good fun and worthwhile. The end does not necessarily have to be literally the end of the day; it could be the worker going home, or someone sitting in a chair, intent on reading a book for the evening. An opening shot could be a portrait or, as the essay follows the course of a day, a shot of the subject waking up or drawing the curtains back, or perhaps leaving the house to go to work or school.

When photographing children, keep your shots fairly simple – concentrating on the child when he or she is doing something. Children tend to freeze up if asked to pose, so encourage them to act spontaneously by involving them in a game, or photograph them playing with friends. As children are so unpredictable, don't hesitate – shoot whatever you see the moment it happens. Have your camera set for the available light and pre-focused to between four and five metres, keeping the aperture as small as possible to increase the chance of having the subject in focus. It is very difficult to shoot 'composed' shots of children and far better to work quickly and on the spur of the moment. You may produce a few bad shots, but you will have many more opportunities to catch striking and memorable images.

Remember to move yourself down to a child's level and to experiment with slow shutter speeds and panning with the action. Vary the pace of your pictures, having some with a lot of activity mixed with others of quieter moments.

Whoever you choose as your subject, include some shots showing the relevant context. These could be of the person's home, with them looking out of a window or door, or a businessman in front of his office, or a pilot with his aircraft in the background, or a child in his room.

You will need to shoot at least five rolls of film during the course of the day. This may sound a lot, but especially if photographing children you will use it very quickly. You should, however, then have enough material from which to select really good shots for a revealing and interesting picture essay.

Print up the pictures in a variety of sizes and, perhaps if you have a gift in mind, paste them into a blank book or album. This would make a far more appealing present than a static one-off shot. A variety of shots is important, so select a balance of close-ups through to 'context' shots; the eye reads the story better if the essay has pace. If it is to be a gift, type up a short biography of your subject and paste it into the front of the book. Even if it is for a member of your family, make your presentation as professional as possible; set the pictures square to the page, unless you decide to lay them out at a deliberate angle. Make sure the prints and pages are neat. Look at magazines such as the Sunday supplements to see how they treat the layout of their stories.

This project could be shot in colour or black and white: the choice rather depends on your choice of subject, as well as personal preference. Black and white does have an urgency that translates well in reportage work and would be a good choice if covering a serious business day, while colour indicates more 'fun' and would be suitable for photographing the day of a child.

The Essay

David Osborn chose to concentrate on the working day of two council workers, having first asked both their and the council's permission. He used 400 ASA black-and-white film and two 35 mm SLR cameras, with a 28 mm, a 50 mm, and a 135 mm lens. Throughout the essay, selected from seven rolls of film of thirty-six exposures, the men get on with their work seemingly unaware of the camera, the only exception being the first rather formal portrait. The shoot was particularly successful in offering a variety of types of shots as well as interesting angles, showing that the photographer moved around a great deal. The final selection was made in more or less chronological order, with each picture introducing another part of the story.

Above: *From the portrait, the essay starts with a picture of loading up the truck at the depot. Taken from one side of the truck on the 28 mm lens at 1/125th at f4, the picture not only catches some of the dust from the tarmac, but was taken at the moment that allowed a good view of the loader and its operator.*

Right: *As one of our two characters gets into the cab of the truck, the photographer, already in position inside, used the 28 mm lens set at 1/250th at f2.8 to catch the moment. The picture clearly indicates that the worker is about to set off, to begin a day of mending roads and pavements.*

Opposite: *The opening picture identifies our characters – evidently manual workers by the clothes and background. Taken on the 50 mm lens at 1/125th of a second, the picture is slightly under-exposed. The aperture was set at f4 and it would have been worth another shot at a stop wider. However, the photographer had to work fast and there is enough detail for reproduction purposes.*

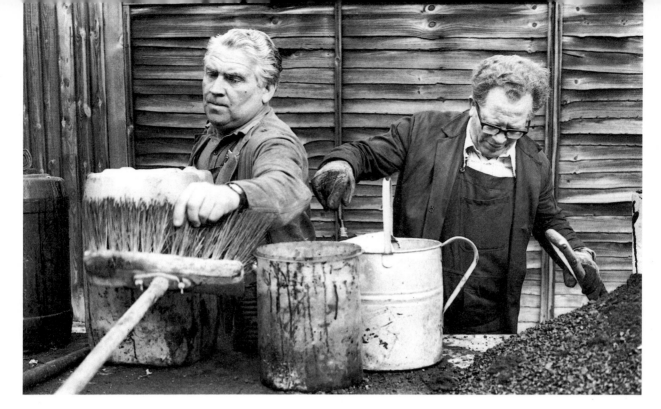

Above: *A wonderful picture with the two men seemingly unaware of the camera. The photographer used the 50 mm lens with the aperture set at f4 and a speed setting of 1/125th of a second.*

Right: *Hard at work, the action was frozen by using a speed of 1/500th of a second with the aperture on f2.8. The 28 mm lens gives a good depth of field and both the angle and the wide lens help to capture the moment of the pickaxe coming down towards the camera, making this a dramatic shot.*

Left: *The 135mm lens allowed this close-up, with the tarmac on the back of the truck leading the eye towards the subject, as well as being part of the information of the picture. By focusing on the man, on an aperture of f4 at 1/125th, the short depth of field renders the foreground out of focus.*

Below: *Caught mopping his brow, one of the two men finds the work heavy going. Taken with the 135mm lens again at f4 at 1/125th, the photographer did well to catch this human moment.*

136

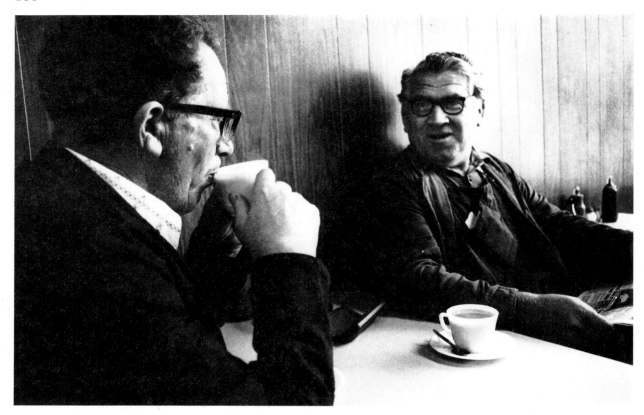

Above: *The previous shot leads on well to this picture of a tea break in a local café. The men seem untroubled by the camera as they chat. The lack of light in the café forced a speed setting of 1/60th at the widest aperture of f2.8 on the 28 mm wide-angle lens.*

Right: *The background of this shot puts our worker in context. Taken on the 28 mm at f4 at a speed of 1/125th of a second, another variation of angle, looking slightly up, helps to pace the story.*

Left: *Laying the tarmac. This picture was also taken on the 28 mm wide-angle lens at 1/250th at f2.8. A back shot helps to add variety to the essay.*

Below: *Back to another close-up with the man's face half-hidden by his brush. Concentrating on his work, he does not seem to notice the camera, and the 135 mm lens helped the photographer to keep his distance. The aperture was set at f2.8 and a speed of 1/250th of a second ensured the moment was frozen.*

138

Right: *Of the twelve shots in this particular sequence in the shoot, only this one caught the moment of the worker looking at his watch, indicating that it is almost time to finish, while the children continue to watch, fascinated. The photographer used the 28 mm lens, at an aperture of f2.8 at a speed of 1/250th of a second.*

Below: *A final shot of an upturned wheelbarrow on the back of the truck indicates that the day's work is done. By this time the light was fading, so a speed of 1/60th was required to allow an aperture of f5.6, to give some depth of field with the 28 mm lens.*

□ □ □ □ □ Project No 24 □ □ □ □ □

My Street

Time: over twenty-four hours. Picture essay.

The more familiar our surroundings, the less we take notice of them. Even if one lives somewhere famous, one quickly stops noticing the things that catch the eye of the stranger. On holiday we tend to see far more detail – of architecture, design, pattern, and texture – than we do at home. The best photographs taken of, say, London, are rarely taken by Londoners. What is strange and interesting to the visitor is hardly looked at by those who live there.

This project is a picture essay to encourage you to discover photographic opportunities quite literally on your own doorstep. It means, as do many of these projects, getting up very early. Have you ever really looked at your street, or at the surroundings of your house or flat, at dawn from a variety of angles? Be up and about before the light starts to break and photograph the entire length of the street as the first light appears. Try photographing from both ends of the street, experimenting with focus and aperture. Bracket all your shots, as the light changes very rapidly. Bear in mind the direction of the light and move around to exploit it to the full. Don't forget to shoot into the light as well. Then move up and down the street and photograph houses and details, such as a window with closed shutters or curtains, choosing those that have interesting patterns and textures, with highlights and shadows.

Capture the beginning of movement – the street coming to life. It could be someone setting off very early for work, the postman arriving, people drawing curtains, street cleaners and delivery men. Keep going back to the ends of the street as the light changes and rephotograph the early shots again. As the day gets underway there will be a lot more activity – opportunities for candid shots of neighbours talking, children playing, dogs being taken for a walk. If you have access to an elevated position, take a shot looking down on the street. Wait until someone or something moves across your line of vision and is in a position to add maximum interest to your shot. Then take several pictures, both horizontally and vertically, and experiment with various camera angles.

If an architectural detail looks appealing, but the light on it is flat, work out the direction in which the sun is moving and return to the shot later. Don't worry about the weather – wet roads, mist, or dew on grass all add texture and interest to a picture. Look at brickwork, paving stones, fences, gates, walls, and other surfaces, and photograph them when the light picks up their details and texture, so reinforcing pattern and colour.

Photograph people leaning out of windows or sitting inside – perhaps a cat or dog is looking out instead. If the window is closed, use a polarizing filter to reduce glare and reflection. Experiment with car bumpers, side mirrors, and windows to give a reflected image of the whole street. When photographing people at home, however, remember to respect their privacy – so always be polite and ask permission first. Interesting shots can also be taken of the ever-neglected back view; someone walking away or painting a door, for example. Let the image fill the frame. Experiment, too, with different apertures – a wide aperture will keep the background out of focus, which may be important if you wish to concentrate on a single image in a close-up shot.

Be sure to cover all aspects of the street from different angles, using the camera both vertically and horizontally. Photograph as many as possible of the buildings, vehicles, pets, and people, young and old, that make up your street so that you will finish with a complete record of your neighbourhood.

The scene will be constantly changing as you look around during the course of one day. With a combination of close-up, middle-distance and long shots, wide-angles and

worm's-eye views (pictures taken from ground level) you will notice and record things that up to now you had probably taken for granted. It is every bit as interesting as a street in a foreign town; you just have to go out and look for it.

If you live in an apartment block, you can still shoot this project, with the added advantage of having a high vantage point from which to photograph the street below. With care, lean out of a window or over a balcony and shoot straight down. If you have a wide-angle lens, you might be able to include most of your street from this strange angle, which could make a great opening picture to your story.

In the country, pick a street in the nearest village, finding one that has character, with shops or businesses that are very much part of the country way of life. Use your picture to convey that it is a country street, more tranquil than its city counterpart. As people in villages tend to know their neighbours more than in the city, watch for people greeting one another and try to convey the friendliness of the place.

□ □ □ □ □ Project No 25 □ □ □ □ □

Reflections

Time: one month. Mosaic or picture essay.

Reflective surfaces create unusual and exciting images. In black and white, reflections can heighten your awareness of tone and line. In colour they produce abstract images, like paintings.

The sharper and clearer the surface the more realistic the reflection will be. A mirror will give an almost 'true' image, whereas a puddle on a pavement, due to the greyness and uneven surface of the stone, will give a distorted, abstract one. A still pond in good bright light will produce a mirror-like reflection of the surrounding trees and buildings, but throw a pebble into the water and the ripples will transform the image.

There are two approaches to this project. The first is to shoot the subject, be it a boat, a person, or a building, *and* its reflection. The second approach is to concentrate on the reflection itself, cropping out the real subject. For a picture essay it is better to concentrate on one or the other, although as an opening shot to the essay you could include a shot of both the subject and its reflection to lead the viewer into the story, followed by a series of reflections alone.

Look for photographic possibilities in as many types of surface as possible – water, glass, metal, and so on. Focusing is important in any close-up work, as both subject and reflection should be in focus. Use the smallest aperture for the maximum depth of field. This problem does not arise with a distant scene, as both subject and reflection are far enough away to be both in focus.

A polarizing filter, while not affecting colour, can be turned to reduce the light reflecting off a surface, so making the image appear stronger. The subject need not be instantly recognizable as, for instance, a tree or bus –

abstract forms can make exciting pictures. The quality of the light is obviously an important factor – the stronger the light source, the stronger the reflected image – but do not just wait for a sunny day. Street lights in a puddle at night, its surface disturbed by rain, produce interesting colours and shapes. Raindrops on a car bumper add a texture and extra interest to the reflection.

Look for less obvious surfaces than water or mirrored buildings. There are hundreds of surfaces, from a kettle to sunglasses, that offer the photographer a challenge. Remember to take into account your own reflection – it could make an exciting series of self-portraits, but it could also ruin what you had wanted to achieve.

Shooting from unusual angles helps with abstraction, so move around the subject and study its shape from various positions before taking any pictures. Try moving up and down – the reflected image changes each time you move, so exploit it. If you find a shop window (old glass distorts more than new), wait and watch for people and traffic to pass by, looking at their images from a variety of positions before shooting. You may have to wait a few minutes before another bus or person goes past, but patience is the virtue of the good photographer.

Crop in close, so that the image fills the frame – either the subject and its reflection, or just the reflection. The photograph will lack impact if too much of the surrounds are included. A shot of lights in a puddle will lose some of its power if the rest of the street can be seen behind it. Keep it simple, and the image will speak for itself.

The Essay

Having taken one shot of this huge telecommunications tower (The Post Office Tower) as part of this project, Paul Reeves then decided to concentrate on finding it reflected in as many situations as possible. The results, all shot on 125 ASA black-and-white film, are very graphic. Using a 1A Skylight filter on

28–50 mm and 80–210 mm zooms on a 35 mm SLR, he also added a polarizing filter to reduce glare, without cutting out the reflected image. The selection was made to show the tower in different surfaces and degrees of abstraction. In some the tower is very clear, while in others there is only a section or obscured image. The pictures were also chosen to give a balance of scale and distance, and some were cropped to achieve this.

In this picture, taken with the 28–50 mm zoom, the tower is clearly defined and the angle emphasizes its size. The pattern of the windows of the building does not distract from the subject, and the vertical lines help its scale. It would, if possible, have been worth taking a second shot of the same reflection with the tower dead centre, rather than slightly to one side. However, it is still a strong image, which was taken at 1/125th at f11.

Above: *The glass building in this picture distorts the image of both the tower and another building reflected in it. The photograph has been cropped along the bottom to cut out the roof of a car, which would distract from the subject. Taken from the far side of the road, the distance of this shot balances well with the previous one and the one to follow. It was taken on the 28–50 mm zoom at 1/125th of a second at f11.*

Left: *Back in close, on just a section of the tower, this shot is more obscure and difficult to 'read'. The simple pattern of the windows reveals just enough of the tower to be interesting. It was taken on the 28–50 mm zoom at 1/125th at f8.*

Right: *After the previous close-up, another full image,
rather distorted by the mirrored windows. The pattern of
the regular windows makes the uneven shape of the tower
seem strong, and it is balanced in composition by the
reflection of the building behind it. It was shot with the
80–210 mm zoom from a distance, with the speed set at
1/125th and the aperture at f11.*

Below: *This landscape shot has a strong graphic quality
as it not only reflects the tower and other buildings and
trees, but shows a little of the inside of the building and
some of the reflection from the street. The arms of the
people on the couch behind the glass help to bring the
eye to the centre of the picture, with the tower neatly
placed between them. The reflection of the legs of the
photographer on the sofa are just allowable in this case,
as they add to the bizarre nature of the picture – falling as
they do below the body of one of the people
on the couch. It was shot with the 28–50 mm zoom at
1/125th at f8.*

Left: *Another portrait shot, used small as the image itself is simple and strong. The picture was cropped at the bottom to cut out some of the pavement, which unbalanced the composition by leading the eye to the base of the building rather than up to the tower. It was taken with the 80–210 mm zoom at 1/125th at f11.*

Below: *Back to a landscape picture again, with the vertical lines of a blind on the window to juxtapose with the upright tower, which is thus more difficult to define. The filters on the 28–50 mm zoom have helped to emphasize the clouds, and the speed was again set at 1/125th with an aperture of f8. The right-hand side of the shot was slightly cropped to exclude some distracting surrounds.*

Above: *Using the same lens and setting as the previous shot, the photographer found another window, but this time with horizontal lines. This and the previous picture were deliberately put in sequence to set each other off, but this one did not need cropping.*

Right: *To end the essay, this shot was selected as it was so different from the others. It was cropped so that the small reflection of the tower in the motorcycle's mirror becomes a more important part of the picture. It was taken with the 28–50 mm zoom at 1/125th at f8.*

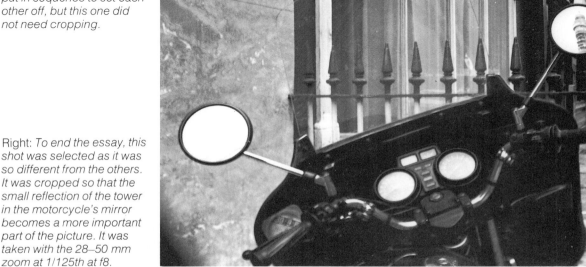

Subject File

The projects in this book are intended as a challenge for your photographic skills and to help you to find photographic possibilities in any situation. Test your skills by using them first as assignments to be followed – and then as points of departure. All the projects are, of course, open to individual interpretation, for no two photographers will ever come up with the same solution. Each project has, however, been limited by subject and time for good reason: a specific assignment will encourage you to think your approach through carefully and to ask yourself why, for instance, you are choosing a particular angle, and what you want to achieve in each picture and how it will relate to others in the mosaic or essay. In short, you will begin to take better pictures, for random photography without regard to the possibilities of each shot frequently results in frustration.

Ultimately, however, there is only one way to improve your photography: go out and experiment, and don't be afraid to use film. You will never know whether a shot has worked until you take it. To encourage you, the following are some suggestions for expanding on specific projects.

From the 'Street Art' project, which itself could result in several sets of pictures, you could go on to photograph the street games of children or make a mosaic of pictures of street furniture – a study in shape, design, texture, and colour. From 'Abstract Form', try another approach by concentrating on simple objects and moving them to different positions while the shutter is held open on a time release. 'A Day in the Life', although presented as an ordinary day, could capture the excitement of a very special one, such as someone's birthday or graduation. 'Primary Colours' could be expanded into another project to show the many variations of one colour, such as reds,

covering the spectrum from pink to the deepest red. 'Views From a Window', which suggested using the window-frame itself as the frame for the picture, could be expanded into a series of pictures all taken through different surroundings. Look through pipes, gaps in the trees, at people walking through tunnels, or the view through an arch. After completing that set, go further still and use something in the foreground that only partially frames the picture, such as a tree, or telephone wires running across the sky, or a fence which cuts a line across the image.

'Take One Tree' suggested taking one shot per month for a year, to show the changing seasons. This could be extended to almost any subject and even turned into a calendar. You could concentrate on townscapes or landscapes, or on more intimate, close-up shots of different people wearing the various clothes of the season – figures in heavy coats and hats, fighting through the snow, for example, or people leaning into the wind or sunbathing in the park.

Think up your own projects and decide whether they would be best in black and white or colour. Set yourself a time limit and discipline yourself to stick to it, and use your imagination to find new solutions to old ideas. By doing this, you will make yourself explore possibilities that you might not have thought existed, for only by taking a lot of pictures and studying the results will your photography improve. However simple or sophisticated your photographic equipment, the limitations of a specific project will make you think about what you want to achieve and the result will be better pictures.

The following list is a subject file of ideas which, like all the projects in the book, you can photograph in your own style and then use as a point of departure.

The Four Seasons Shoot just four pictures, one for each season, either in the same place or at different locations, and try to capture the mood of the seasons by using the light – the cool morning light for spring, the brighter sunlight for summer, the warm light of late afternoon for autumn. Bleak landscapes and skies will speak for winter, especially when photographed in turbulent weather.

The Circus This colourful subject offers marvellous photographic opportunities. There is the actual performance, of course, but so much variety elsewhere that you could concentrate solely on behind-the-scenes shots – setting up the big tent, rehearsals, clowns making up, the circus animals, and so on. Remember to ask permission before shooting and with luck the members of the circus will co-operate. For the performance itself, you will need to use a fast film and to be careful of the glare of the spotlights. Look for the crowd's reactions to the more spectacular and dangerous acts, such as the trapeze, and for children's reactions to the clowns. Both are frequently much more interesting than the performance itself.

A Historic Place Imagine that you have been asked to show a historic building, famous for someone who once lived there, to people who have never seen it before, but using only your photographs. Start with an overall shot of the place or alternatively with a detail, perhaps a portrait or manuscript, that makes it clear either what the place is like or who it is famous for. Your pictures must be very varied and include details of the objects and mementos that a visitor would associate with the place, as well as more general shots of rooms and gardens.

A Poem Find a poem that interests you because of its subject and interpret it through your pictures. It could be a simple set of landscapes of the area, or type of area, that the poet is writing about or a more abstract interpretation, but capture the mood of the piece.

Old Friends Older people make very good subjects for the photographer, as their faces are full of character. Shoot at least ten pictures of old people sitting together talking, for example, or walking in a park, or simply holding hands. It could be that the 'old friend' is a dog, so take a back view of dog and owner together. Another approach would be to arrange some portrait sittings, with the aim of conveying through body language and facial expression the friendship and character of the subjects.

Two Square Metres of Garden Even such a small area contains a lot to be studied. Start with an overall shot, taken from a chair or a ladder, looking down on the plot. Then move in to examine plants and insects in close-up, until you have photographed the plot from all angles in addition to its particular details.

A Railway Station Railway stations are very photogenic places, offering a great variety of shots of often rather grand architecture. Begin with overall shots of the place and then concentrate on details of design, pattern, and wonderful metals. Usually a covered area, but with light pouring in at the open end, a railway station's atmosphere is a strange mixture of quiet and chaos, happiness and sadness; try to convey it. Include plenty of shots of people waiting for trains or rushing to catch them, meeting one another, or hanging out of windows saying goodbye, perhaps silhouetted against the light.

A Parade Far more interesting than the parade itself are the people watching it – children at the front, dwarfed by surrounding adults, people watching out of windows or climbing to a vantage point. Begin with a series of shots of them and then photograph details of costumes, flags or banners, posters advertising the parade, intense crowd shots, and so on, filling the frame with the image each time. Take some behind-the-scenes shots, too, of those actually in the parade itself, adjusting costumes or floats. Look for those special, off-guard moments, such as

someone looking tired or out of step; try to capture the unusual. As a final shot photograph the parade from an original angle, either looking down from a height or perhaps a wide-angle view from ground level, but make the crowd and the detail the main part of the story. Do not try to cover too much in each picture, or the result will be confusing. Experiment with panning at a slow speed with part of the parade as it passes by.

Street Fashion Fashion changes very rapidly and makes a good subject to photograph on the street. Take overall shots of groups that dress in one style, then look for details of unusual hair styles, badges, shoes, and hats. Either use a long lens or ask people to pose for you – most are only too willing to do so. Do not forget the ever-neglected back view.

A Graveyard This may sound morbid, but can produce some very successful pictures. Do be respectful, however. Look for interesting epitaphs and tombstones, and find out if anyone famous is buried there. A sad place, so find signs of it – perhaps some rather old flowers on one grave, and another that has been neglected. Find a good position for an overall shot, perhaps juxtaposing the graveyard with a nearby tall building.

The Zoo Although most people love to look at the animals, the photographer is often put off the zoo by the bars on the cages. A long-focus lens can be helpful, allowing you to photograph animals some way off, and by using a fairly wide aperture and keeping the camera close to the wire you can make the cage seem to disappear. Alternatively, focus on the wire or bars of the cage with the animal appearing out of focus in the background, and so make the point that a wild animal is living in captivity. Find out when the animals are fed, as until then they often hide away in the back of their quarters. Some zoos put on special shows with the seals, chimpanzees, or big cats at feeding time, which can offer exciting pictures. Watch also for the reactions of children, who are often delighted and amazed at such spectacles.

A River Water fascinates most people, whether a fast-flowing river or a quiet trickling stream. Somewhere near you, whether in town or country, there is a river. Make a photographic study of it, combining overall shots, taken either standing by the river or, if possible, from a height, with more intimate ones of all the activities of people and wildlife. Experiment with interesting reflections on the water or use a polarizing filter to cut out the reflection, so giving a clear view of fish, pebbles, and plants. Watch for people fishing in the early morning or late evening and for boats and swimmers. Look for signs of wildlife on the river banks; settle down behind a bush or in long grass and wait patiently until birds and animals show themselves.

Do not neglect city rivers – many great cities are built around one – for they are usually buzzing with activity. Again, take some overall shots but also look for details of boats, buildings, and waterway signs. Cover your subject at a variety of times of day and from both banks so that later you will have many different shots to choose from.

The Characteristics of a Nation Whatever your own nationality, another always has characteristics that seem so different – perhaps quaint or eccentric, flamboyant or reserved. These qualities are far more evident in other countries than in your own, so next time you travel abroad shoot a picture essay that conveys your impressions of the country through its people. Avoid stereotypes and concentrate instead on the small details that are peculiar to a country. You do not see Parisians wearing berets and carrying strings of onions, but you do see elegant women, men playing boule, people in coffee houses, and so on. Each country has its own customs, its own way of doing things, so try to capture them. You will return home with a far more interesting set of pictures than the usual snaps of famous places.

Shop Windows Look for interesting or unusually shaped windows, displays, and signs. These are often better shot square on, especially if you want to include any features on the outside of the shop. To stop any lines of perspective appearing, shoot with a long-focus lens from the other side of the road and cut out any reflection with a polarizing filter. There is great potential in this subject, with wonderful displays of fish, meat, or fruit and vegetables, for instance, both inside and outside shops almost everywhere. Find at least ten eye-catching examples.

The Seaside An ideal excuse for a day trip, the photographic possibilities at the seaside are numerous, even if the weather is bleak. Look for candid shots of people sunbathing – or trying to – and for shots of bathing huts in a row or a mass of bodies lying elbow to elbow, exaggerated by using a long lens. Explore the patterns in rows of sunhats or lobster pots, for example, or photograph someone selling refreshments. Keep the idea in each picture simple, with a strong focal point or pattern. If the weather is bad, look for the shot of a solitary walker on the beach, or the rain beating down on an ice-cream stall. Concentrate more on details than overall shots, which tend to appear confused if too much is happening in them.

Self-portraits An opportunity to use the delayed shutter release, having thought of an interesting shot beforehand. Alternatively, catch your own reflection in shop windows, glass buildings, water, and other reflective surfaces, shooting from the hip so as not to obscure your face. Try the same idea with a series of shadows.

Still Life Find a colour print of a painting of a simple still life and study how the painter has interpreted the light. Then find suitable props and try to re-create the painting and its atmosphere. Place your objects, which should be as close as possible in size, shape, colour, and texture, in the same arrangement, with the light falling from the same direction as in the painting. As most painters prefer a natural north light, look for a similar position in your home and see if the light has the same quality.

Montage Photograph a scene – it could be a room, a landscape, or a townscape – in sections. Take at least twenty pictures in colour or black and white and print to postcard size. Then arrange the pictures to re-create the scene in a rather surreal way – they need not match up exactly, indeed the image will be more exciting if they do not. The final arrangement need not be square as it could be interesting to leave out parts from the edges.

Skylines Roofs and skyscrapers have a lot of pattern and interesting textures. With roofs, find a vantage point from which to photograph across a town, focusing solely on the roofs themselves. With skyscrapers, photograph straight up the side of the building, experimenting with different lenses to find which gives most impact of size and scale.

Picture Editing

The pictures that you take for the projects will no doubt include shots that are extremely good in their own right, but the key to compiling a successful picture essay or mosaic is to look at every picture not only for its technical qualities and composition, but for its relationship to the other pictures in the set.

For colour, professionals would always use transparency film rather than colour negative. You will need a light-box and an eyeglass when examining transparencies. The light-box should be colour-balanced to enable you to see the true colours in the transparencies. The eyeglass should be of high quality, enabling you to examine the pictures in detail without straining your eyes. Do not try to edit transparencies on a projector, as you will constantly need to refer back to other pictures to assess their relationship to one another.

To edit black-and-white pictures it is best to start with a set of contact sheets, which can be either printed the same size as the negative or enlarged. Use either an eyeglass, held close to the contact but not touching it, so allowing light in, or a magnifying glass. Some eyeglasses have a battery-powered light for viewing contact sheets, while others have glass or Perspex sides which allow light to fall on the image. To mark up the pictures that you want to print use a grease pencil, which will not damage the contacts and can easily be wiped off. You can also mark any cropping with it.

Editing a Picture Essay

If you have shot several rolls of film, begin by putting them in the order in which they were taken. You may not end up using them chronologically, but it is a good way to start. Take the first roll and lay the pictures out from left to right across the light-box (assuming they are already mounted up), again in order of shooting. If you have used colour film that is developed as a strip or several strips, use a grease pencil to mark up the pictures worth considering. Always mark on the transparent cover of the film or along the black edge, never on the film itself.

Look at every picture carefully, bearing in mind the theme of your essay and how you want to tell the story. Then repeat the exercise, eliminating any that are badly under- or over-exposed, or out of focus. If a picture is only slightly under- or over-exposed, but has a powerful image or a lot of information in it, keep it on the light-box. Remember also that pictures that at first appear either confused or boring can always be cropped to make them more powerful.

Picture editing is a process of elimination partly for technical reasons and partly to select down to the best pictures that tell the story. Having made a preliminary selection, go back over the photographs remaining on the light-box and select those that capture an exciting moment or a quiet mood, bearing in mind all the time the subject of the story, how you approached it when shooting it, and whether the pictures really express your intentions.

If, as suggested in the projects, you bracketed all your shots, you should have three exposures of most of your pictures. Study each exposure carefully, especially with more abstract subjects. Has one a slightly richer tone which enhances the subject? Is another slightly under-exposed, yet adds atmosphere to the picture? If you have several similar shots of people, look at each several times and make comparisons. Is the composition in one better than in the others? Does the background distract in one more than in the others? Is the subject's face hidden by a hand or is his expression noticeably better in one

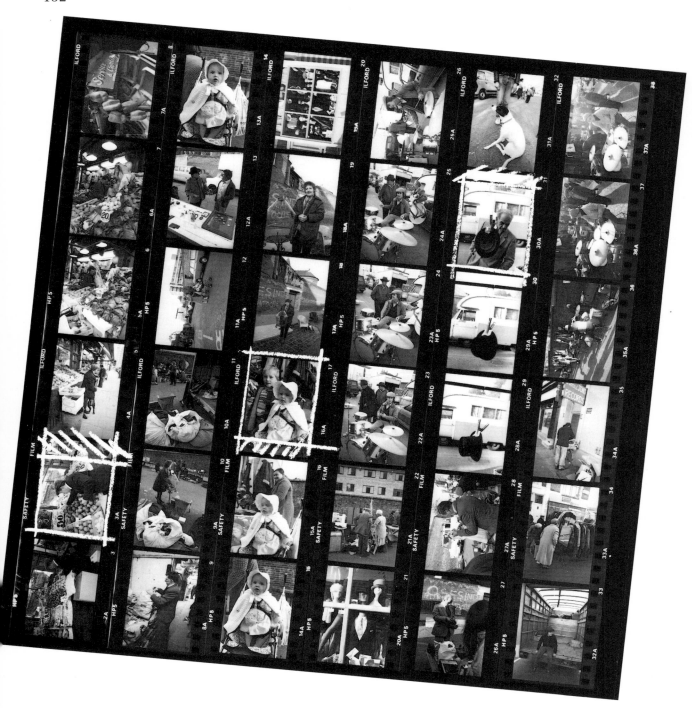

Edit black-and-white film by examining the contact sheet with an eye-glass. Look carefully at each picture, considering its technical qualities as well as its composition and relevance to the story. Mark pictures selected for printing with a grease pencil, which can later be removed by wiping with a tissue dampened in lighter fuel.

153

shot? Perhaps the better expression is in a picture with part of another person entering the image – could it be cropped to allow you to keep that expression? Is the focal point very strong in one picture, yet the action better in another? Consider again whether cropping would increase the strength of the composition. Has one shot got a fine detail in it that you missed taking in close-up while on the assignment? Perhaps it could be blown up and the surrounds cropped out.

By this stage you should have edited down to about one-third of the roll. Do not forget to mark the frames of selected pictures with a grease pencil and to mark the whole role with a number '1'. If you are editing unmounted film then you can simply separate, mount, and mark your selections. Repeat the exercise with every roll of film shot on the project, numbering the rolls as you go.

Next, lay out in order as many of your selections as will fit on the light-box and look for possible shots with which to start the essay. Put these in a line down the right-hand side of the box. The opening picture is all-important; it must lead the viewer into the story. It might be an intriguing shot – a picture of your subject opening the curtains, for instance, taken from outside the house early in the morning, if you are editing 'A Day in the Life'. Alternatively, for 'A Craftsman at Work', it might be a close-up of the raw materials needed by the craftsman, which gives a hint of what is to come without revealing all. If instead you decide to select the craftsman's finished product, you could treat the rest of the essay as a visual flashback. Similarly, 'A Day at the Races' or 'Market Day' could start with a shot of all the litter left behind after everyone has gone home. Select about six possible shots for the opening picture that are not only technically good, but have content relevant to the story. Once you are more experienced in putting together an essay the first picture may not be the first you select, but it is a good starting point.

Now look at the other pictures in relation to the opening ones. If you are treating the essay chronologically, you may go on to your 'Day in the Life' subject breakfasting or leaving for school or work. In a craftsman's studio it may be a picture of the craftsman selecting raw materials or beginning the first process. As you will have more than one shot of the same activity, pick out the picture with the best composition and strongest focal point, and which gives an insight into life style or character. With the project on a street market, it might be setting up stalls or unloading vans; at the races, it might be leading the horses out of their boxes. All the pictures in your essay must be interesting in their own right and add information to the total without repeating it. If you have two shots of different horses coming out of their boxes or of different children on a swing, select the one with the stronger focal point and strength of composition and take the other off the light-box. If both are good but carry the same information, on the other hand, keep one in and put the other along the top of the light-box, as you may need to return to it once the essay begins to take shape.

A picture essay should have pace, which can partly be achieved by printing up at different sizes later on. Some pictures will warrant being very large, while others, with less power but a lot of information, can be printed quite small. These smaller pictures, known as point-pictures, could be a shot of a document relating to a famous person, for instance, or a detail of a shop window that would get lost in an overall view of the front of the shop. Alternatively, if the detail is more interesting than the overall shot, consider printing it large and the overall shot small, or with the point-picture inset into the larger shot. Pace should also come from selecting a variety of overall shots and then juxtaposing them with middle-distance and close-up ones.

If you have approached your assignment as a broad theme, such as agriculture in general rather than specifically sheep farming, an essay could consist of just five very good shots, each leaving the viewer in no doubt as to what the essay is about – one of each type of agriculture in your area, for example. Leave

154

out point-pictures in an essay like this, as they will make it more confusing.

Whatever the subject and approach, a good picture essay must convey atmosphere. It is, for instance, a craftsman's dedication and concentration that must be captured, and not just the technical details of his work. 'A Day at the Races' should be exciting, so select pictures that show the build-up of excitement – of both the crowd and individuals. The shot of the actual race could be the final picture in the story, if the crowd has proved a good subject, or it could be in the centre of the essay, with the final shot being either of the winner or of the unhappy losers packing up to go home.

Arrange and rearrange the pictures on the light-box, imagining that you are laying them out for a magazine story. Try each of your selected opening pictures also as the final shot, looking to see which best rounds off the story. The final picture should be as strong in image and content as the opening shot, yet not repeating the information in it. The pictures in the main part of the essay should tell the story, with each leading on to the next, and any point-pictures acting as transitions to link the sections together.

An example of the selection one might make for a day at a race course might be:

1 Opening shot: a full-frame photograph, printed large, of the crowd on the stands, all looking through binoculars at the races.
2 A fairly large shot of horses being unloaded from a horse-box, with a point-picture of details of the name of the stables on the side of the horse-box, cropped from the larger picture.
3 Middle-distance shot of a horse being groomed, next to point-picture of close-up of the jockey putting on boots.
4 Close-up shot of someone reading a sporting newspaper.
5 Middle-distance shot of people placing bets.
6 Saddling up the horse (same horse as in

3), with point-picture of details of racing colours.
7 Wide-angle overall shot of horses in parade paddock with crowd looking on.
8 Middle-distance shot of the jockey in intimate conversation with the owner.
9 Overall shot of course and crowd as horses go up to the start and the crowd leans over the rails. Point-picture of starting prices.
10 Dramatic shot of horses in the race, taken either with a long lens as the horses come towards the camera or panned from the side to give the feeling of speed.
11 Shot of part of the crowd or a person reacting to the result.
12 Close-up of jockey (same jockey as in earlier pictures), still on his horse and reacting to winning – or losing. Point-picture of torn-up betting slip on ground.
13 Overall shot of all the litter after everyone has gone home, perhaps with someone sweeping up.

The editing process is the same for black and white as for colour, although you will probably need to print up more pictures than you need. Sometimes it is easier and cheaper to have two sets of contact sheets and to cut up one so that you can move the images around when making your final selection, before printing up. This can also help you to decide what size to print the pictures and where, if at all, to crop them. Otherwise, use a grease pencil to mark up possible opening shots (marked 1), second shots (marked 2), and so on, and then run through a potential essay starting by looking at a single 1, followed by one 2, etc., until you can edit down to about the number of pictures you want to use.

The numbers will vary, of course, according to the amount of activity in the essay and how many pictures you can use without repeating information. Do not try to include too many – it could be as few as five, each one a clear, easy-to-read image, powerful and dramatic in composition.

Editing a Mosaic

Lay out, mark up, and select your shots in the same way as for a picture essay. With a mosaic, however, look for balance of interest in each picture and for balance of colour and tone. Each image should be a good example of your chosen theme which will look even more interesting when set with at least five others. You could use more if the subject has enough examples, each different from the others. Make sure that each subject is of similar size within the frame of the shot − although the actual size may vary enormously. You can achieve this quite simply by cropping the pictures to increase the size of the image. It is easier to keep all the pictures the same size and proportion when printing them, or to have just one central larger image.

Cropping

The best way to see whether a crop would improve a picture is to use pieces of L-shaped card placed over a transparency or contact and moved around until the offending background or shadow is removed, or until you find the best way to crop in on the detail you want to blow up later. Experiment with your pictures, using the cards to see whether the composition would be improved by cropping in closer to your subject, from either one or perhaps all sides. Mark any crop by using a grease pencil on the contacts, and mark the mount (never the original) on a transparency.

Scaling Your Pictures

If you want to know how wide a picture will be if you increase its depth, or how deep if you increase its width, you can use a proportional scale. Alternatively, the following formulas will also give you the new size. The depth and width refer to the image required, which might be all of the print or only a cropped part of it. You must know first either what width or what depth is required. To find the required depth, use the following formulas.

$$\frac{\text{Width to be}}{\text{Width now}} \times 100 = \text{reduce or increase } to \text{ X per cent of present size}$$

Therefore:

$$\text{Depth now} \times \frac{\text{width to be}}{\text{width now}} = \text{depth to be}$$

Alternatively, to find the required width:

$$\frac{\text{Depth to be}}{\text{Depth now}} \times 100 = \text{reduce or increase } to \text{ X per cent of present size}$$

Therefore:

$$\text{Width now} \times \frac{\text{depth to be}}{\text{depth now}} = \text{width to be}$$

Another way to scale a picture is to place a piece of tracing paper over it and to draw a rectangle over the area you wish to blow up − see the diagram below. Extend the left-hand and bottom lines of the rectangle as shown, and then draw a diagonal line from the bottom left-hand corner up through the top right-hand one. The dotted lines represent the sides of the larger, blown-up picture. Wherever they bisect the diagonal line, the larger picture will be in proportion to the original.

Using Your Pictures

The photographs that you assemble from your chosen projects will look good in the album or slide show, as well as framed on your wall. They will also give you a good basis on which to build a portfolio, should you be thinking of turning professional, especially in the field of editorial and photojournalistic photography. The projects will show that you are capable of dealing with an assignment and that you think in the right sort of way – that is, using your photography to interpret a brief and to tell a story visually. They will also show that you can cope under difficult conditions, are able to deal with a variety of situations, and that you follow something through to the end.

Select your best essays and mosaics and print them up, remembering to print a variety of sizes (two or three sizes are enough, as books and magazines have grid formats that limit the options), and lay them out in your portfolio. Colour is obviously expensive to print, so put each set of transparencies in 'viewpacks' – see-through transparency holders – with a typed heading of each project at the top. Each sheet of transparencies should represent the best from one story only. With black-and-white prints, each should be printed to the highest possible quality and carefully laid in order in the plastic sheets of the portfolio.

Needless to say, your portfolio should be clean and tidy with typed captions and headings, as it shows not only your ability as a photographer but your attitude towards your work, which must look professional. Do not include too much and select only your best stories. Ten in colour and four or five in black and white, each with about ten good pictures, is quite enough. If you have one or two stunning pictures that do not fit into a story, use them as an opener to your portfolio, printed large, so that you will catch the attention of anyone you are showing it to. If these are in colour then it is worth spending money on some high quality prints, as they will show that you can deal with both colour and black-and-white photography.

Picture editors and art directors usually look through the whole portfolio first and then at the colour transparencies on a light-box. Make sure that you select the right kind of stories for the person you are going to see. It is no good going to see the art director of a sports magazine with a portfolio full of fashion shots, so first look at the books or magazines of any potential client and then edit your portfolio accordingly. Also ask yourself whether, in all honesty, your pictures come up to a potential client's standards. Two of the biggest mistakes that inexperienced photographers make are first, not to study the sort of work a client deals in, and second to aim too high too soon. Remember, also, to establish whether a client usually prefers either colour or black and white. Your portfolio should be constantly changing for different clients and as your own style develops through taking more pictures.

As competition is very fierce, often from highly talented and experienced photographers, it is very difficult for inexperienced photographers to get that first break professionally. Initially, do not be over ambitious, as you have yet to prove that you can work under pressure and produce great pictures. If you have disciplined yourself to the time and limitations of the projects in this book, on the other hand, you will have already found out to a certain extent how well you fare under pressure and different conditions. As an amateur, you do not have to earn your living by photography and you can always do a project again if you did not get it right the first time. When assigned professionally, however,

you cannot make excuses and ask for a second chance.

One of the best ways to start off is to think of an idea yourself and either approach a newspaper or magazine to see if they are interested or shoot it anyway and try to sell it afterwards. There are problems with both approaches. If you are unknown to a magazine and the idea is a very good one, they may well not want to use you as the photographer or they may have staff photographers whom they have to use. Remember that there is no copyright in ideas. The problem of shooting an idea first and trying to sell it afterwards is that an art director may well say, 'If only you had shot this in another way – you should have spoken to me first'. Furthermore, shooting 'on spec', as it is called, means that you have to foot the bill and you cannot guarantee that you will be able to sell the story later.

On balance it is probably better to shoot a story yourself on something local, but which is not a one-off event, so that if the client does want to add to it, you can easily do so. Do not forget that you should note down the details of all your shots when working on your own, research beforehand what you are going to shoot, and type up detailed captions to your story. Edit down your pictures to a wider selection than you would have for a final story in your portfolio, as you must give the client choice and information.

To find your first story for publication, first look at your market. Buy copies of all your local publications and of ones on special interests that also interest you. Keep these as file copies for future reference. If you visit another town or country, again buy a copy of all the magazines and papers that you might possibly be able to take pictures for, however unlikely it may seem at the time. You never know when you may come across a story suitable for one of them. Using the projects and the Subject File (see p. 146), look at each one and see how it could relate specifically to a story in your area and to a local publication, and then reshoot that project having developed the idea and geared it towards a magazine. Your essay

on 'Local Industry', for example. Perhaps you photographed a local factory and now you hear that it is to be closed down? New pictures of the closed gates and dark building, set beside those you took only a few weeks before, and suddenly you have a story, your pictures saying more than words could to local people. The project on 'The Way It Looks Today' could also make a story, comparing old with new. Read books about your area; you may find mentioned someone or something of interest that you have not heard of before. A little research into where they lived and whether their house still exists, followed through with details of their life, and you have a story of local interest.

Keep your ideas fairly simple – they are usually the best anyway – and thoroughly research your subject. Keep cuttings from papers and magazines of any idea that may be worth more investigation, even at a much later date. Perhaps a road is to be built through a beautiful part of the countryside. Go and take a picture, returning to it after the roadworks have started. It may only be a two-picture story, but it is still a story. Perhaps the local zoo is getting a new rare species. This is likely to be covered by the local paper, but a wider picture story may well be of interest to a more specialist magazine.

The reference section of your library should hold copies of directories that list all the publications in the country, as well as the main publications abroad, cross-indexed by subject. Many magazines offer guidelines as to the type of story they are looking for, so it is worth writing to the ones that might take your work. The timing of placing stories is very important. Magazines work up to three months in advance, so you must learn to think ahead. Newspapers, of course, usually want pictures immediately for publication the following day or week.

When loaning your pictures to a magazine for consideration or use, make sure that each transparency has your name on the mount, with the copyright sign ©. Each print should have a typed self-adhesive label on the back.

Do not use a stamp, as the ink can rub off onto the print lying beneath, and the pressure from a pen may also mark a print. Include both an order number and a reference number, and itemize on a delivery note the colour and black-and-white pictures that you are leaving with a client. This should state the date, the reference number and subject matter of the pictures, and your name, address, and telephone number. The client should sign for these on one copy, which you keep in your files, retaining a second copy for himself. If you have not been commissioned and are the copyright owner of the photographs, you are granting a licence to someone else to reproduce your pictures. The delivery note should also specify the following:

1 The rights that you are selling. This may be for use in a particular magazine, for distribution in one country only, or one-time world rights, which means that your pictures can be used in the magazine all over the world, but that they may not be used for, say, advertising without your permission and further payment.
2 That the client is buying the specified use only and not the copyright, unless otherwise agreed.
3 That you should be paid the agreed fee on publication.
4 That all pictures be returned to you after use.

5 That there should be fixed compensation should the transparencies or negatives be lost, and similarly if the prints are lost. (You can always make another print if you have the negative, but you cannot make another transparency.)

When sending pictures through the post, always pack them well and send them by special delivery so that you will have a record of the client receiving them. When the pictures are returned to you, count them all and check to see whether any are lost or damaged. If some are, contact the client immediately.

Payment

Most books, magazines, and newspapers have their own page rate by which to calculate the price paid for material. This varies greatly, depending on whether the photograph is in colour or black and white, the rights wanted, and the circulation and standing of the publication. Payment is normally related to the size of a picture, which is generally calculated to the nearest size of a full page, half page, or quarter page as appropriate.

Payment for commissioned work varies just as much, according to the scope of the publication. It is usually based on a day rate or flat fee, plus expenses. Professional photographic organizations can offer guidelines, but cannot set fees due to fair trading restrictions.